Collecting Plastic Jewelry

A Handbook & Price Guide

an Lindenberger & Jean Rosenthal

Schiffer Publishing Ltd

77 Lower Valley Road, Atglen, PA 19310

Contents

Copyright © 1996 by Jan Lindenberger

All rights reserved. No part of this work may be reproduced or used in any form or by any means--graphic, electronic, or mechanical, including photocopying or information storage and retrieval systems--without written permission from the copyright holder.

Printed in Hong Kong

ISBN: 0-7643-0024-5

Book Design by Audrey L. Whiteside

Library of Congress Cataloging-in-Publication Data

Lindenberger, Jan.
 Collecting plastic jewelry: a handbook and price guide/Jan Lindenberger and Jean Rosenthal.
 p. cm.
 ISBN 0-7643-0024-5 (paper)
 1. Plastic jewelry--Collectors and collecting--United States--Catalogs.
 I.Rosenthal, Jean. II. Title.
 NK4890.P55L56 1996
 688'.2'0904075--dc20 95-53168
 CIP

Published by Schiffer Publishing Ltd.
77 Lower Valley Road
Atglen, PA 19310
Please write for a free catalog.
This book may be purchased from the publisher.
Please include $2.95 for shipping.
Try your bookstore first.

We are interested in hearing from authors with book ideas on related subjects.

\mathcal{A}cknowledgements

I wish to especially thank Joyce and Jean Rosenthal, from Lake Port, California, for opening up their home and allowing me to photograph their wonderful, massive collection of plastic jewelry. They spent long hours arranging and re-arranging the kitchen so I could work. Due to their love for plastics, their great collection, and all their information, this book was possible.

Thanks, also, to the "Folly Antiques N' Guns Mall" in Erie, Pennsylvania, and to anyone I may have missed.

\mathcal{I}ntroduction

In the collector's world, plastics are exploding! This is true in the field of household collectibles, and in the area of jewelry. Plastic jewelry has become one of the most fun and fashionable items to collect in the 1990s. People appreciate and seek after all the colorful plastic jewelry from the 1940s through the 1970s. It can be found in an almost infinite variety of styles: large bracelets; figural pins and broaches in the form of birds, faces, miniatures, and sport related objects; and varied sizes and types of beads. These include the pearlized look and pop beads. Beads strung with waxed string and highly carved or molded bracelets are all the rave of the 90's.

Plastics came from the Greek word "Plastikos," meaning able to be formed or molded into any shape. As the name implies, plastic is often used because it can be molded into many forms and designs that other materials cannot. This has allowed products and designs to be made that were impossible before.

Some 1940s plastic jewelry was made of fine thin plastic called celluloid, including bracelets, earrings, rings and figural pins. It was easy to mold, being heated in hot water and shaped. It was not until the 1950s that plastic was perfected. At that time many more fun collectible jewelry items were being made, including large colorful pins along with massive figural pieces to name a few.

In the 1950s the large plastic beads and the gaudy colors were the "in thing." Iridescent and bright colored beads were in practically every teen's and woman's wardrobe. Mood rings and clear plastic purses were fashionable. Big plastic wild looking buckles and pins were on dresses, skirts, slacks and blouses. Plastic raincoats were colorful and many transparent coats with bright color trim were in style.

Plastic jewelry was not only lightweight and popular but also very inexpensive. It came in many different styles and shapes. Round, oblong, square and oval bracelets were manufactured, along with tear drop and transparent necklaces, pop beads, and flower burst earrings.

The 60s trend stayed about the same, but became a bit more imaginative. Neon was "in," along with Lucite and cast plastic bracelets, earrings, buckles and necklaces with stones, sparkles, rhinestones, and copper wire accents. Plastic stones were used to resemble colorful gems.

The 1970s and 80s trend put plastic into costume jewelry with many items containing precious stones. Many fabulous necklaces and broaches were figural with precious stones decorating the item.

Today plastic jewelry is in high demand. Everywhere people are searching for belt buckles, purses, and, especially, plastic carved beads. Bakelite broaches and bracelets are also sought after, and the high quality carved pieces are increasingly difficult to find. Because of this they are commanding higher price.

In *Collecting Plastic Jewelry*, you will find a variety of plastic pieces. Some very common but getting harder to find everyday. This book is designed for the collector. It can be taken to the flea markets, yard sales, and antique shows, and be used to evaluate a wide variety of plastic jewelry. The information and photographs on these pages will give the collector an overall understanding of plastic jewelry. The price guide, though it may differ from one geographic area to another, will give the collector a good idea of what plastic jewelry is worth on today's market. (Please note that auction prices will definitely differ from shop prices, and that items will differ in price based on condition and availability.)

I hope you enjoy this book and I hope you keep collecting this fun, fashionable and exciting collectible.

Jan Lindenberger
Colorado Springs, Colorado

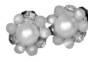

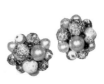
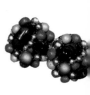

Earrings

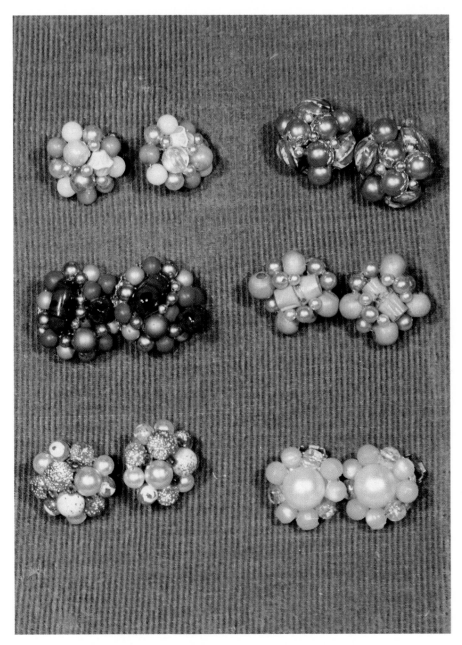

Six pairs of plastic beaded clip-on earrings. 1950s. $3-5 pair

Beaded plastic clip-on earrings. 1960s-70s. $7-9

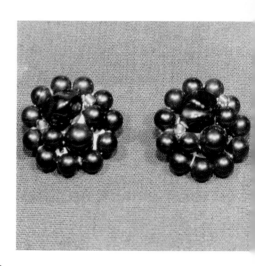

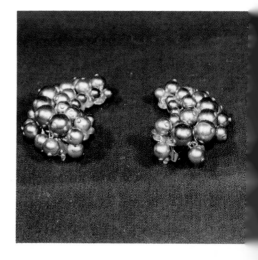

Long multi-colored grape cluster, clip-on earrings. 1970s. $6-8

Clip-on earrings with pearlized beads. 1950s. $5-6

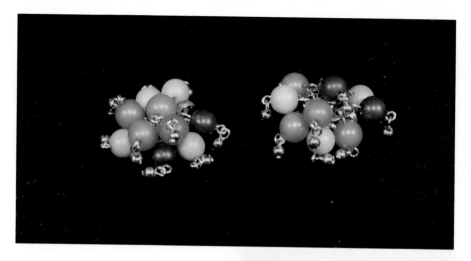

Clip-on earrings with plastic bead clusters on brass dangles. 1960s. $5-7

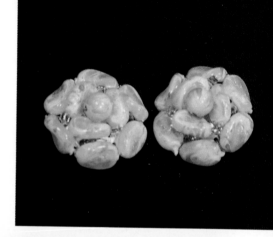

Plastic pearlized woven beads on clip-on earrings. 1960s. $4-6

Clip-on plastic pearl earrings. 1950s. $ 6-8 each

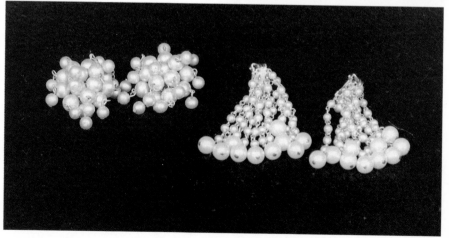

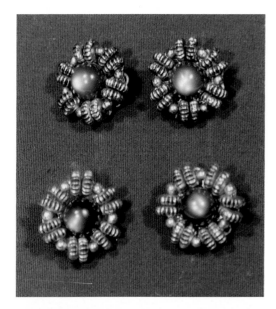

Two pairs of plastic beaded, clip-on earrings with large, pearlized plastic stone in center. 1950s-60s. $5-8 pair

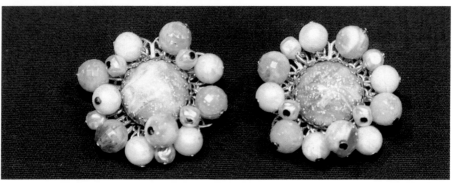

Plastic beads strung with gold wire on metal base. Large round plastic pearlized center. 1960s. $8-10

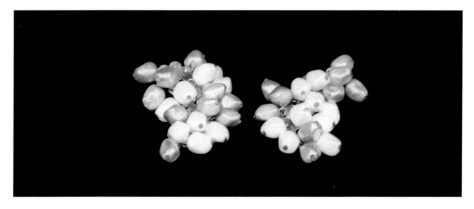

Two-tone plastic seed-shaped cluster clip-on earrings. 1950s $8-10

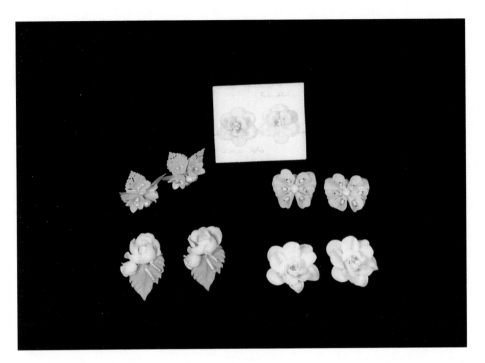

Molded plastic leaf clip-on earrings from "West Germany." 1950s. $10-14 each

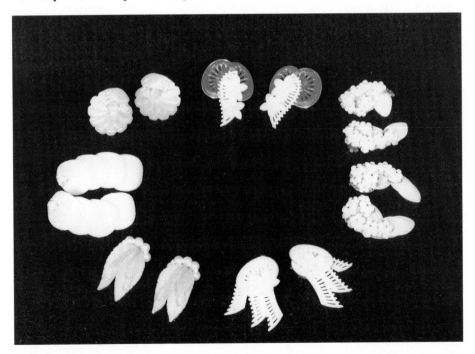

Molded plastic flower clip-on earrings with pearl and rhinestone trims. 1950s.
$12-18 each

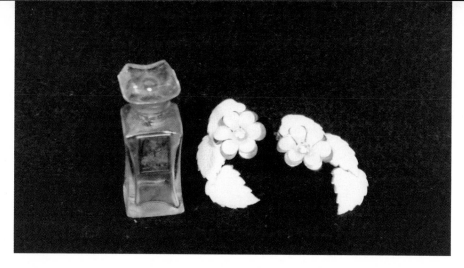

Gold wash frame with plastic insert leaves, and flower with rhinestone center. Clip-on. 1960s. $6-10

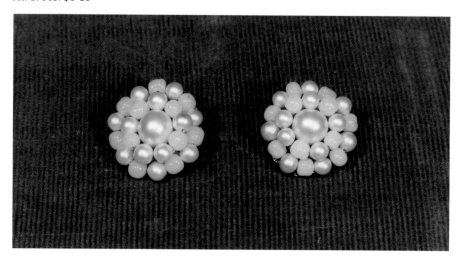

Plastic and pearl beads on clip-on earrings. 1950s. $7-10

Yellow plastic swirl or feather-look earrings with rhinestone centers. 2". 1950s. $6-10

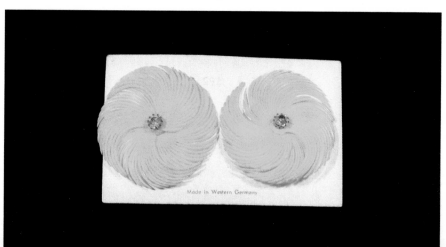

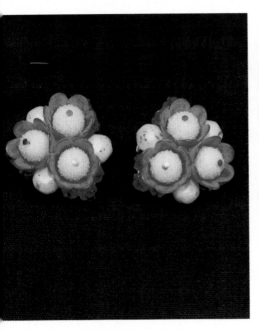

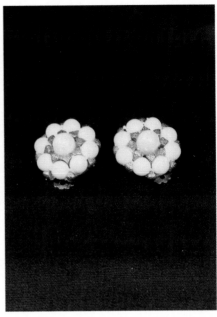

Screw-on plastic earrings with beads set in center of each blossom to form flowers. 1960s. $5-8

Clip-on earrings with metal frame and plastic strung beads. 1970s. $6-8

Screw-on plastic earrings with pearl in center of flower. 1950s. $5-7

Screw-on plastic shell earrings. 1950s. $5-6

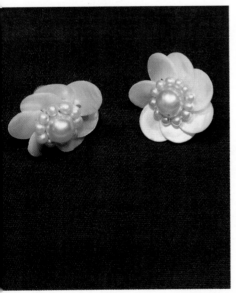

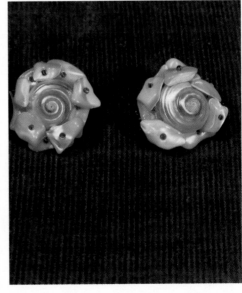

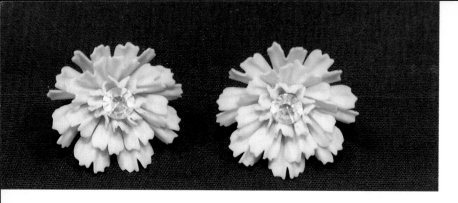

Clip-on plastic flower earrings with rhinestone set in center. 1960s. $8-10

Plastic and pearl beads on clip-on earrings. 1950s. $7-10

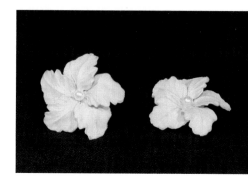

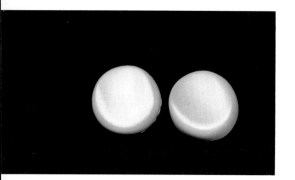

Yellow plastic clip-on earrings with thumb print design. 1950s. $8-10

Plastic half-moon clip-on earrings. 1950s. $8-10

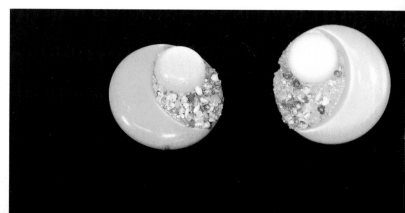

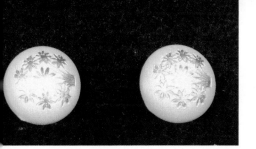

Plastic magnetic earrings with gold color engraving. 1950s. $8-12

Plastic round button, pearlized screw-on earrings. 1950s. $5-7

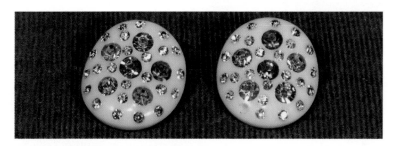

Plastic oval clip-on earrings with embedded rhinestones. 1950s. $15-18

Plastic round button screw-on earrings. 1950s. $6-8

Round plastic pearlized button earrings. 1960s. $4-5

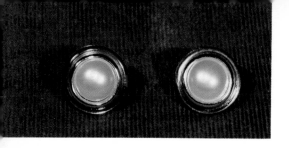

Silver-tone clip-on earrings with plastic stone in center. 1950s-60s. $7-10

Red pearlized plastic half bead inserted on metal frame. "Coro." 1970s. $12-15

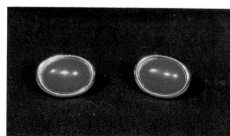

Red, white and blue plastic strung circular discs with large pearl in center. 1960s. $8-10

Square plastic clip-on earrings. 1950s. $6-8

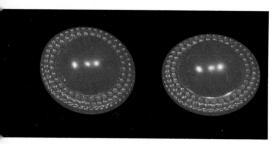

Round disc earrings with bubble center. 1960s. $5-7

Red, white and blue plastic beads on these clip-on earrings. 1950s. $8-12

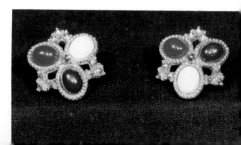

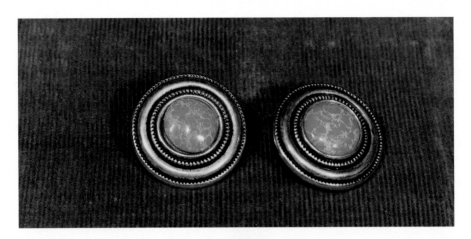

Silver-tone large circular earrings with marbleized stone. Clip-on. 1960s. $10-15

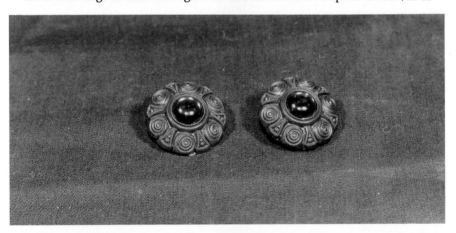

Plastic lace-look clip-on earrings with pearlized center stone. 1960s. $5-7

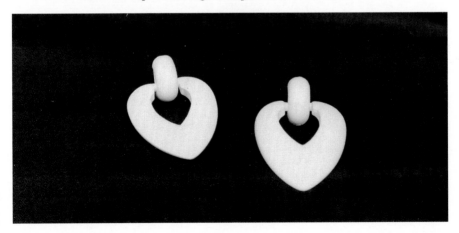

Pearlized hoop with inserted hanging heart. Pin back. 1960s. $10-14

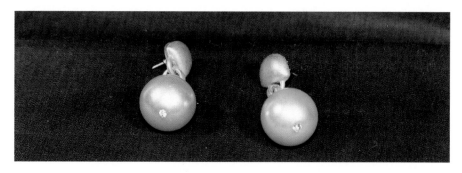

Pink and gold pin back earrings with pearlized balls dangles. 1980s. $5-7

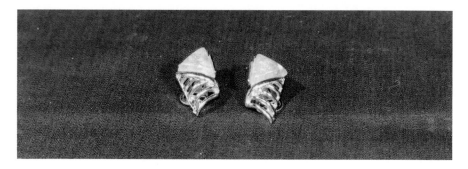

Metal gold wash backing with plastic diamond-shaped inserts. 1970s. $4-5

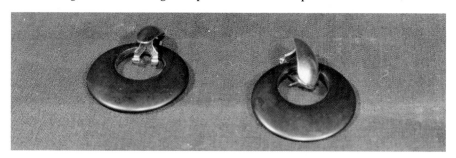

Clip-on plastic earrings with oval cut-out dangles. 1970s. $7-10

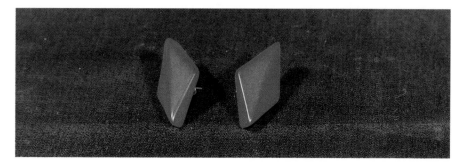

Diamond-shaped raised center pin back earrings. 1990s. $3-4

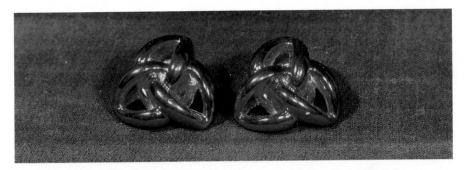

Plastic woven-look florescent clip-on earrings. 1950s. $14-20

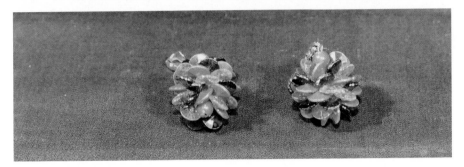

Plastic discs and beads on clip-on earrings. 1970s. $6-8

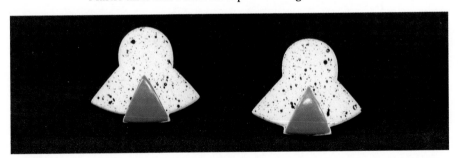

Bell-shaped plastic pin back earrings with speckled finish and green plastic ringer inserts. 1980s. $5-7

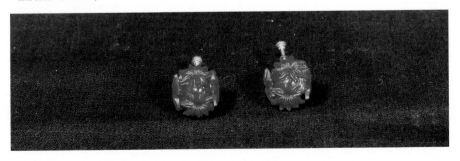

Plastic carved flower screw-on earrings. 1960s. $7-10

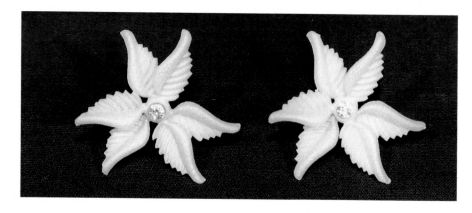

Leaf-shaped screw-on earrings with rhinestone center. 1950s. $10-15

Thin plastic clip-on large flower
earrings with rhinestone centers. 3".
1950s. $15-20

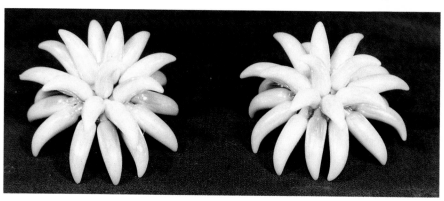

Plastic banana-shaped clip-on earrings. 1960s. $8-12

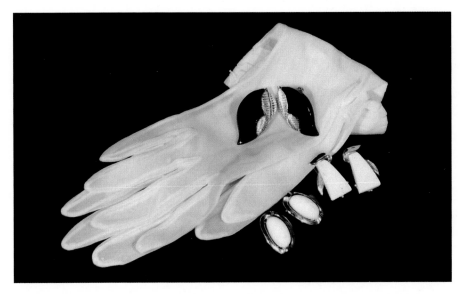

Clip earrings with metal frames and hard plastic forms. 1950s-60s. $8-12 each

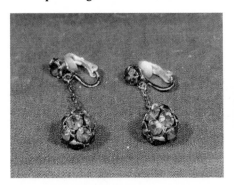

Clip-on earrings with inserted green plastic beads. 1950s. $10-15

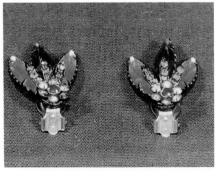

Plastic and rhinestone screw-on earrings. 1950s. $15-20

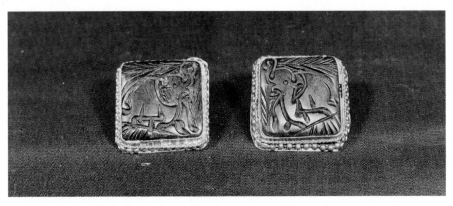

Silver with inlaid plastic carved elephant design. 1940s-50s. $20-30

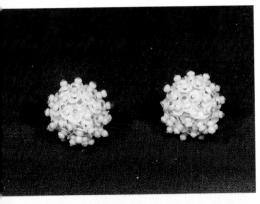

Shell and plastic beads clip-on earrings.
1950s. $7-10

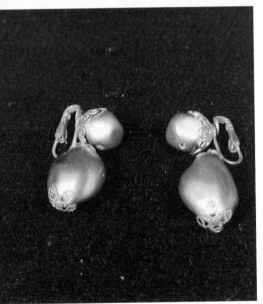

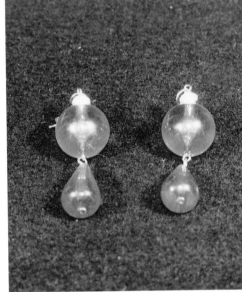

Gold-tone drop, clip-on plastic earrings.
1950s. $4-6

Round tear-drop plastic earrings. 1960s.
$ 8-12

Crocheted lace earrings with plastic
seed-like inserts. Screw-on with floral
design. 1950s. $15-20

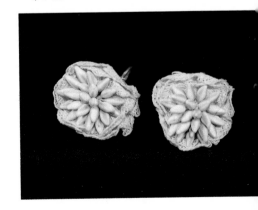

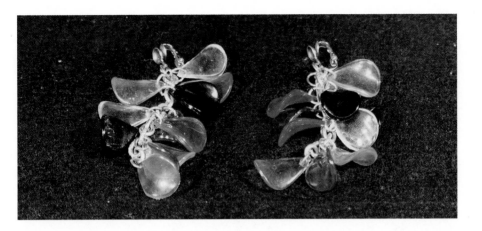

Multi-colored petal cluster plastic earrings, on silver chain. Pierced. 1960s. $10-15

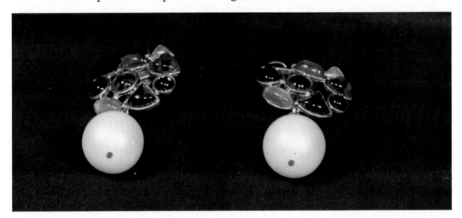

Metal frame with several different colored and shaped beads and a large pearl drop. 1970s. $10-14

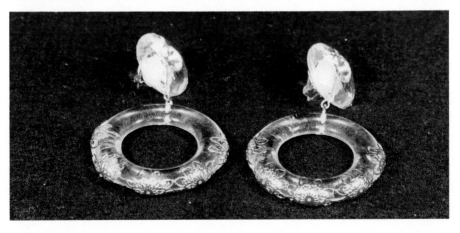

Large plastic bangle drop clip-on earrings with rhinestone center. 1970s-80s. $12-15

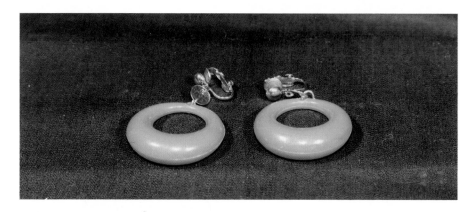

Clip-on plastic earrings with circle drops. 1990s. $4-5

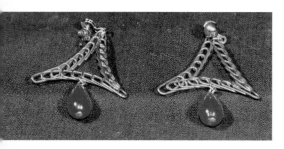

Diamond-shaped woven-look frame with plastic drop beads. Pin back. 1960s. $5-8

Diamond-shaped woven-look frame with plastic drop beads. Pin back. 1960s. $5-8

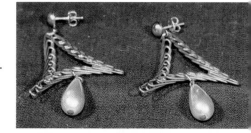

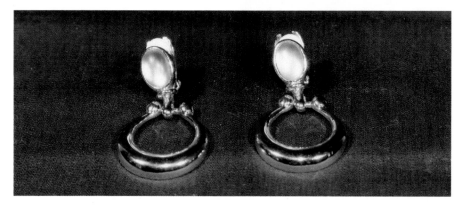

Pearlized plastic half circle beads on gold-tone frame with drop hoops. 1980s. $7-10

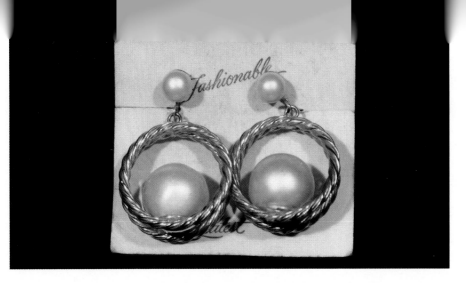

Clip-on ear rings with metal rings and plastic balls. 1950s. $7-10

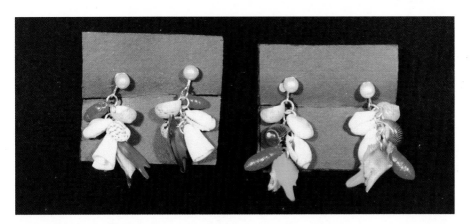

Screw-on plastic shell drop earrings. 1960s. $5-7

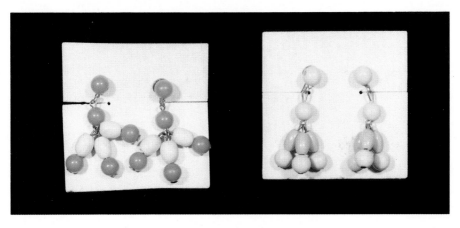

Plastic screw-on drop earrings. 1950s. $4-6

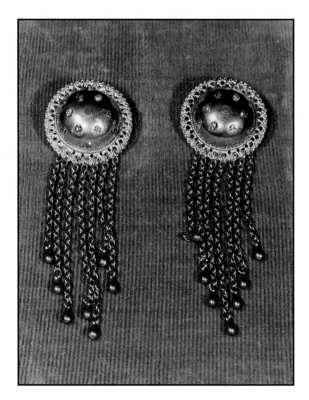

Gold-tone sphere-shaped pierced earrings with multi-colored stones and gold wash drop chains. 1960s. $15-20

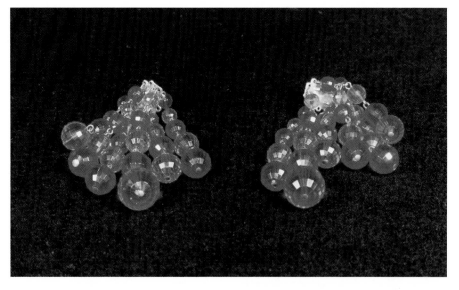

"Bobley" clip-on earrings with long two tone, faceted plastic clusters. 1950s-60s., $8-10

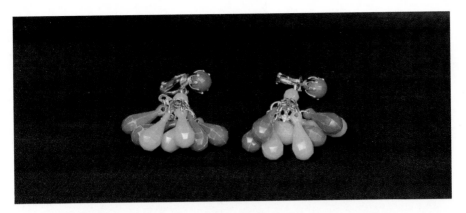

Clip-on plastic burnt orange tear drop earrings. 1960s. $10-14

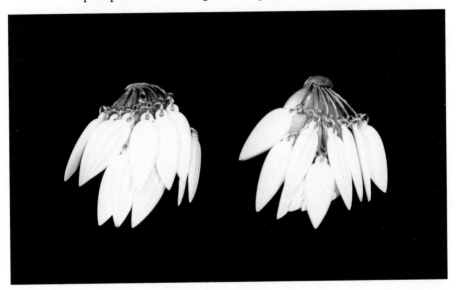

Leaf effect drop clip-on earrings. 1960s. $8-10

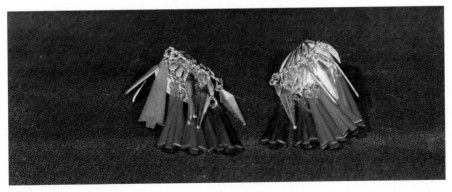

Metal and gold wash frame with plastic tortoise shell drop design. 1970s. $12-15

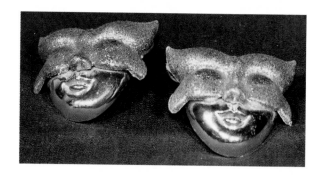

Plastic mask earrings with high gloss and speckled trim. 1980s. $6-10

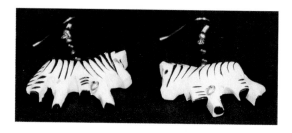

Plastic carved zebra hoop earrings. 1990s. $6-10

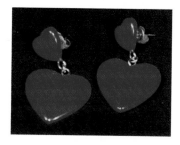

Plastic red heart-shaped earrings with pin backs. 1990s. $4-5

Bracelets

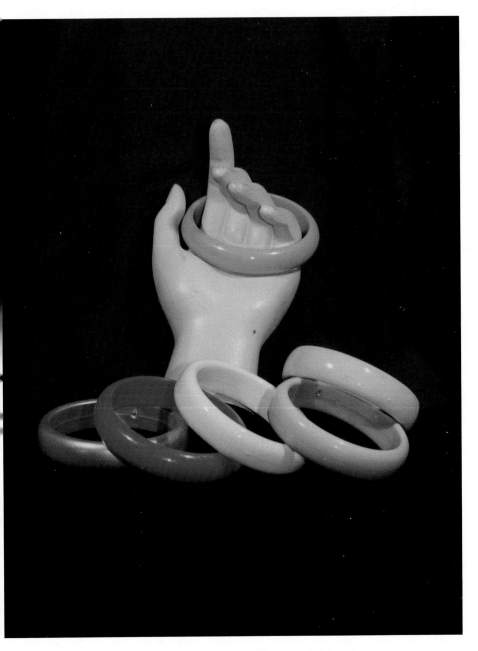

Set of six pastel plastic bangles. 1980s. $3-5 each

Seven multi-colored plastic bangles with gold wire accents. 1940s-50s. $10-15 each

Silver colored plastic bangle with silver spatter effect. 1970s. $4-5

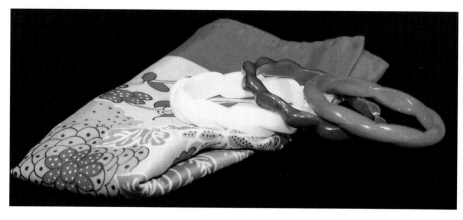

Three plastic swirl-shaped bangles. 1950s. $5-7 each

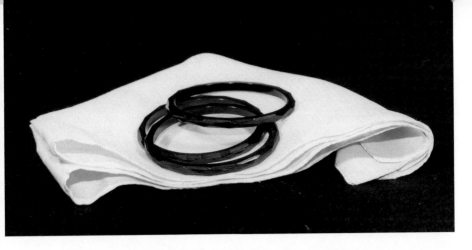

Three narrow faceted plastic bangles. 1940s-50s. $18-25 set

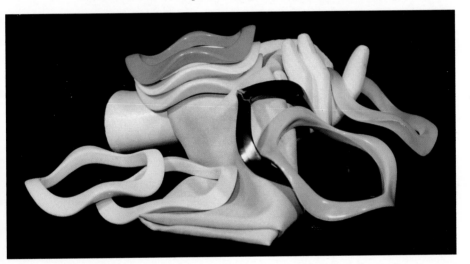

Eight plastic shaped wavy bracelets. 1960s. $3-4 each

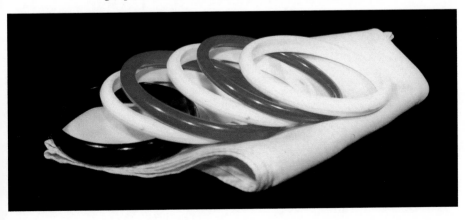

Six colorful plastic bangles. 1980s. $3-5 each

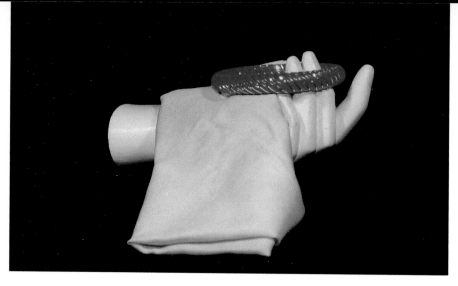

Red plastic swirl bracelet with gold wire accents. 1970s. $8-10

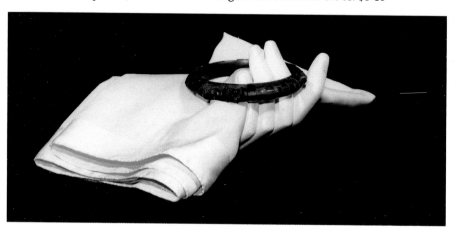

Black plastic bracelet with carved African figures. "Very unusual". 1930s-40s. $30-40

Fuchsia colored plastic carved-look bangle. 1960s. $10-14

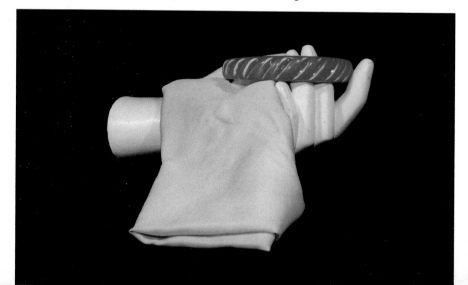

Marbleized plastic bangles. 1970s. $10-15 pair

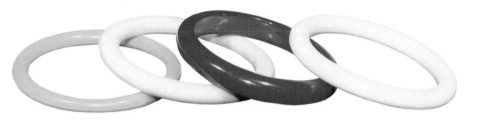

Four plastic round bangles. 1960s. $8-12 set

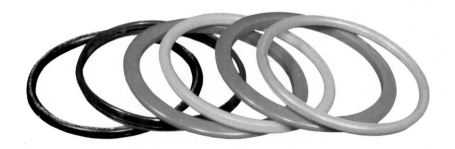

Six narrow plastic bracelets. 1960s. $4-6 each

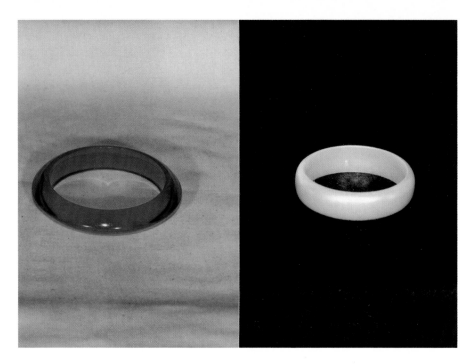

Clear hard plastic bracelet. 1960s. $10-14 Silver frosted plastic bracelet. 1970s. $6-10

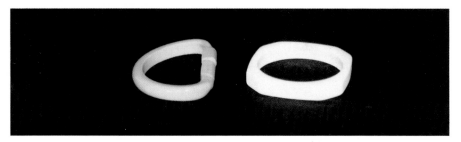

Left: soft plastic pen bracelet; right: plastic round bracelet. 1960s. $8-12 each

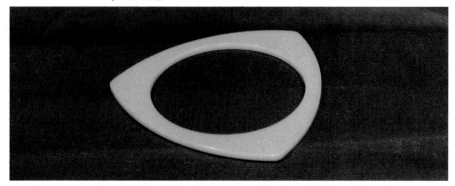

Triangular Bakelite bracelet. 1950s. $30-40

Red oval Bakelite bracelet. 1950s. $30-35

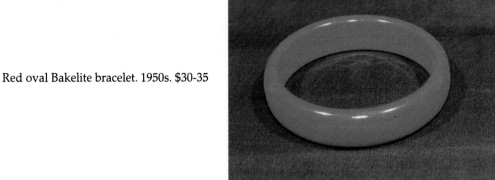

Oval wide bakelite bracelet with string design. 1960s. $18-22

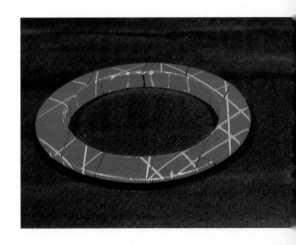

Red plastic, narrow to wide, molded plastic bracelet. 1960s. $40-45

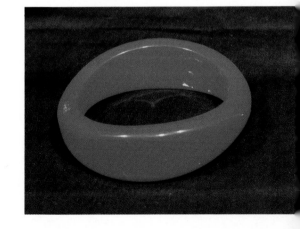

Orange Bakelite oval bracelet. 1960s.
$25-30

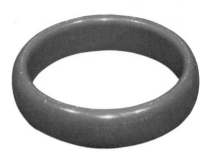

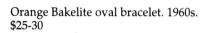

Plastic symmetrical white bracelet.
1960s. $15-20

Oval red Bakelite bracelet. 1960s. $20-30

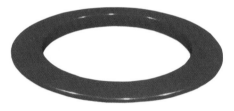

Clear plastic tube bracelet with glitter.
1960s. $4-6

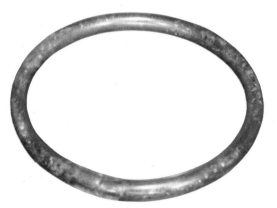

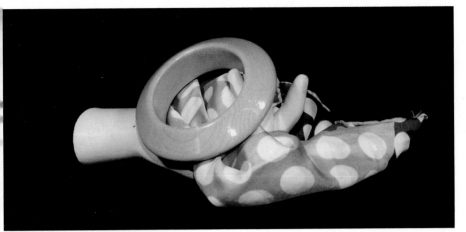

Wood grain-look plastic bangle. 1980s. $5-7

Two plastic bangles. "Hong Kong". 1980s. $4-6

Ivory-look plastic bracelet with geo-metrical facets. 1970s. $8-11

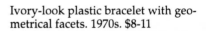

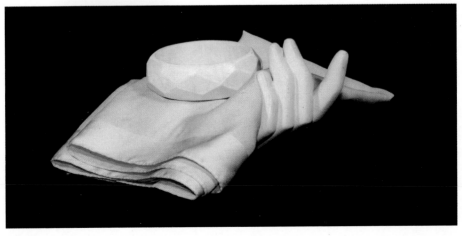

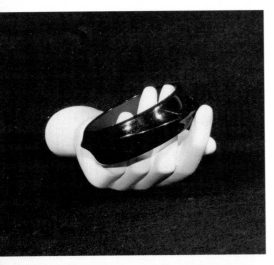

Black plastic swirl bangle. 1950s-60s. $8-10

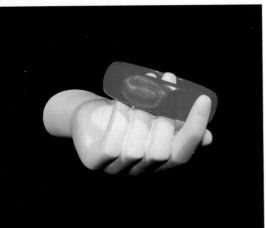

Red plastic molded edge bangle. 1960s. $10-12

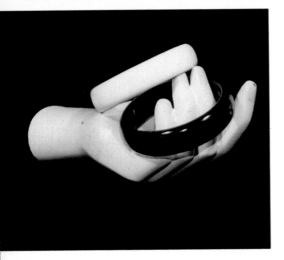

Black and white plastic bangles. 1970s. $7-10

Hard plastic rope design bangle. 1980s.
$10-15

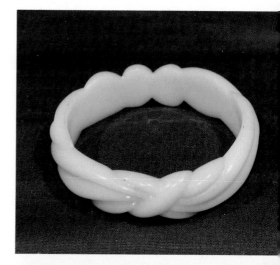

Aqua marbleized plastic bracelet. 1960s.
$20-30

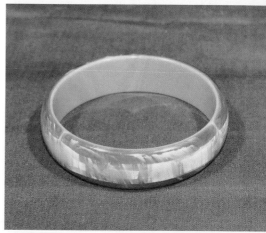

Molded carved-look narrow bracelet.
1950s. $35-40

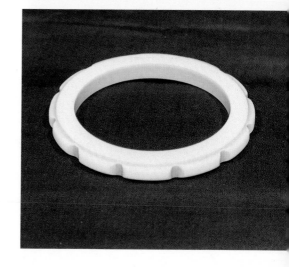

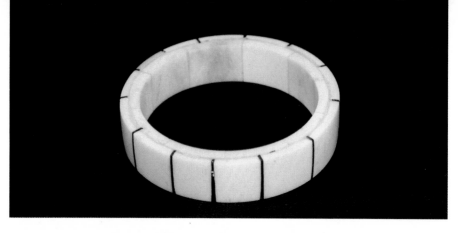

Plastic double carved bracelet. 1950s. $30-35

Plastic swirl bangle with gold wire accents. 1950s. $8-12

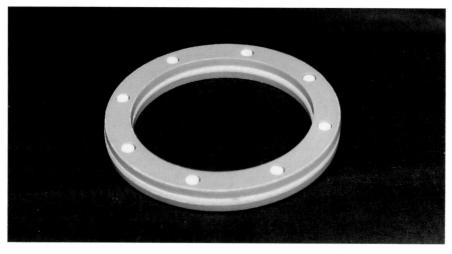

Hard plastic cream and tan layered bracelet with plastic pegs. 1950s. $40-50

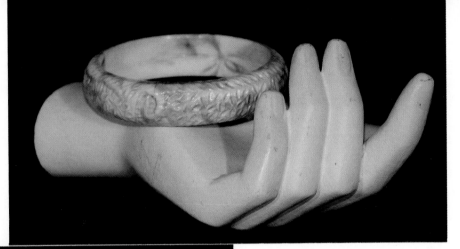

Swirl pressed plastic floral bracelet.
1950s-60s. $15-18

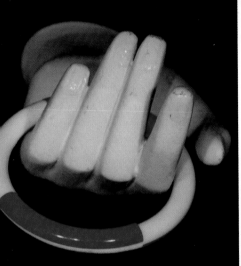

Red and white round plastic bracelet
with geometric design. 1970s. $10-15

"Buch-Reichmann" ash grey deco-look
plastic bracelet. 1980s. $25-30

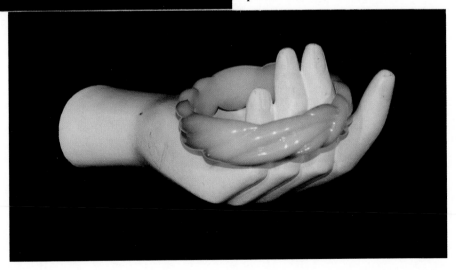

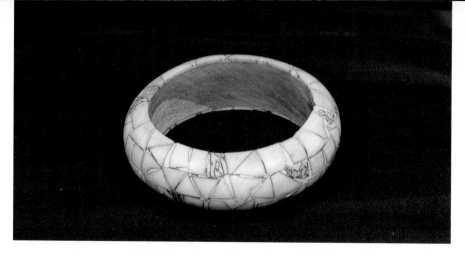

Hard marblized plastic bracelet with inlaid design. 1970s. $20-25

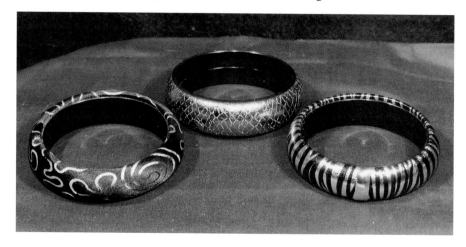

Plastic bracelets. 1980s-90s. $5-7

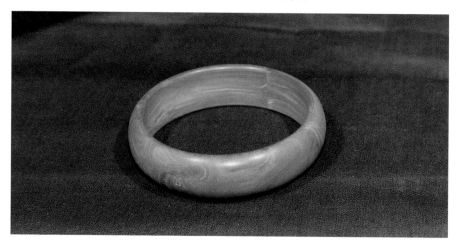

Orange oval swirl Bakelite bracelet. 1950s. $40-50

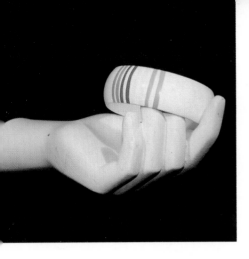

White plastic bangle with multi-color stripes molded in. 1960s. $7-10

Wide band plastic bracelet. 1960s. $18-22

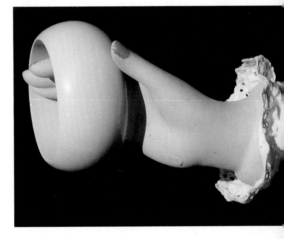

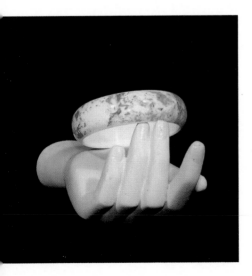

Orange and white swirl design plastic bangle. 1970s-80s. $10-14

Narrow grey swirl plastic bracelet. 1960s. $15-20

Wide band mod design bracelet. 1960s-70s. $30-35

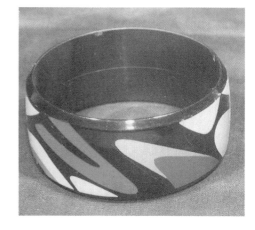

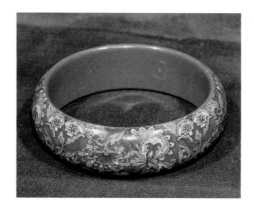

Molded floral plastic bracelet. 1950s. $20-25

Wide band plastic bracelet in pink, turquoise, and black with gold trim. 1950s. $40-50

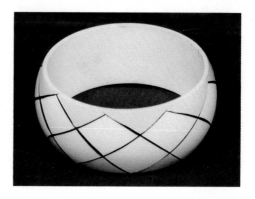

Wide band white plastic bracelet. 1950s. $20-30

Molded bracelet in green swirl plastic with sea shell design. 1960s. $20-25

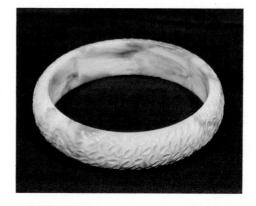

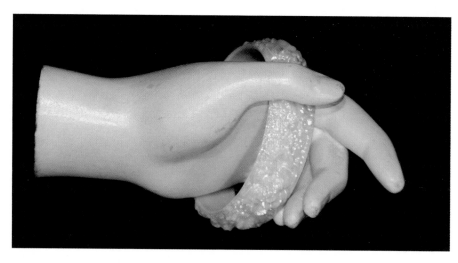

Yellow iridescent floral plastic bracelet. 1970s. $8-10

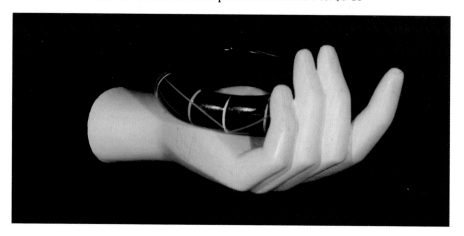

Black plastic bracelet with string design. 1960s. $12-18

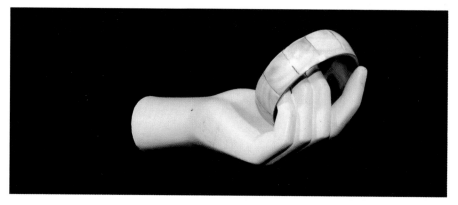

Brass bracelet with plastic "mother of pearl" inlay. 1940s-50s. $30-40

Plastic square bracelet with swirl effect. 1950s. $20-25

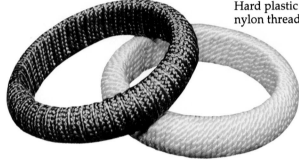

Hard plastic oval bracelets wrapped in nylon threads. 1970s. $5-6 each

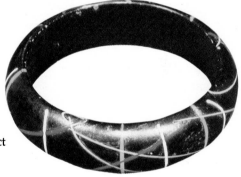

Plastic round bracelet with string effect pattern. 1950s. $20.0-25

Flexible Bakelite designer bracelet. 1950s. $45-55

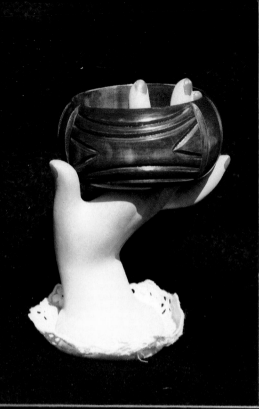

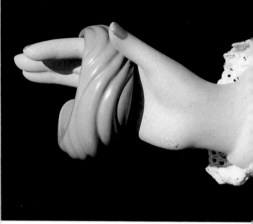

Plastic swirl bracelet. 1960s. $15-20

Pressed pattern wide band Bakelite bracelet. 1960s-70s. $30-40

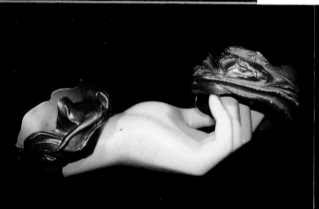

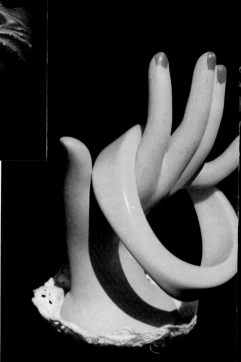

Metallic blue plastic molded bangle. "Artist signed," 1980s. $15-20 each

Yellow Bakelite bracelet. 1950s. $40-50

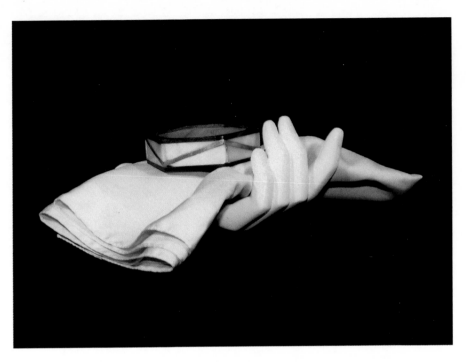

Lavender and black plastic with brass inlay accents. 1930s-40s. $30-40

Inlaid blue and black plastic bracelet. 1960s. $25-30

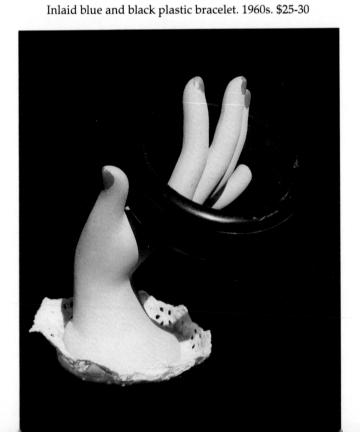

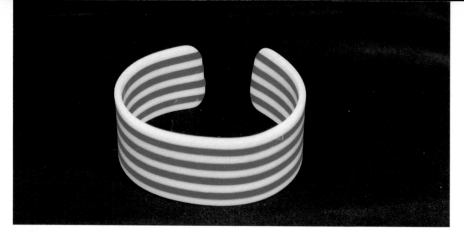

Bendable red and white plastic bracelet. 1970s. $15-20

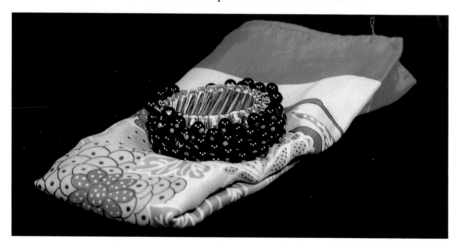

Silver and metal stretch bracelet with black plastic round beads. Marked "Japan." $30-40

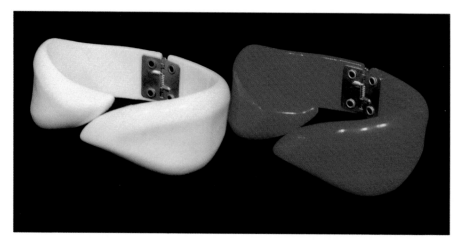

Hinged red and white plastic bracelets. "Hong Kong," 1980s. $15-20 each

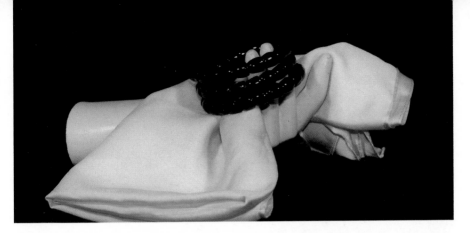

Coil "snake" bracelet with black plastic beads. 1940s. $25-30

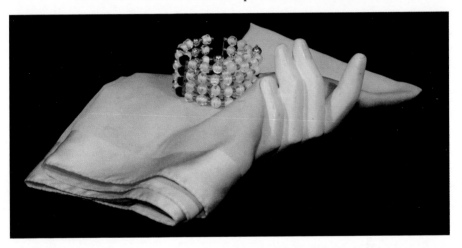

Four strand expandable bracelet with wire bound plastic and glass swirl beads. 1950s. $25-30

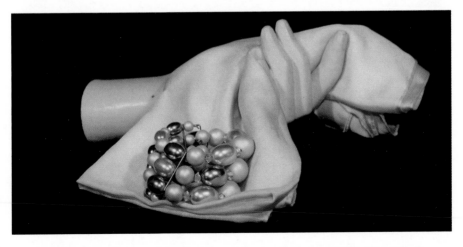

Multi-color plastic beaded bracelet with crystal spacers. 1940s-50s. $20-25

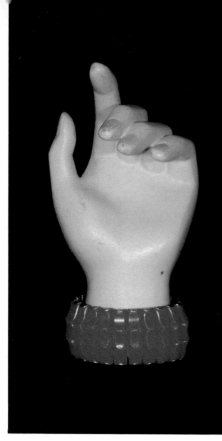

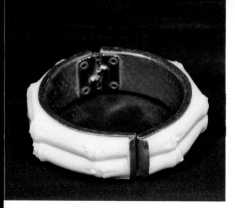

Gold-tone bracelet with bone-shaped inlaid plastic. 1960s. $15-20

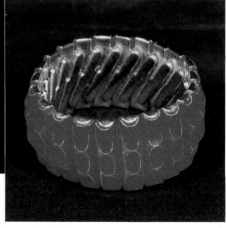

Red plastic expandable bracelet with metal frame. "Hong Kong," 1950s. $35-40

Red plastic inserts on an expandable bracelet. 1950s. $40-45

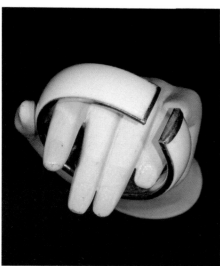

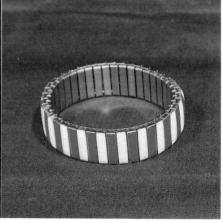

Plastic expandable bracelet with metal frame and clasp. 1960s. $18-22

Red and white expandable plastic insert bracelet. 1960s. $35-40

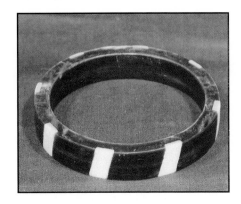

Plastic black and white inlays on gold-tone bracelet. 1950s. $20-25

Tortoise shell light weight bendable bracelet. 1940s-50s. $50-60

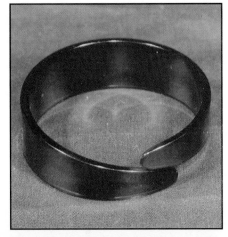

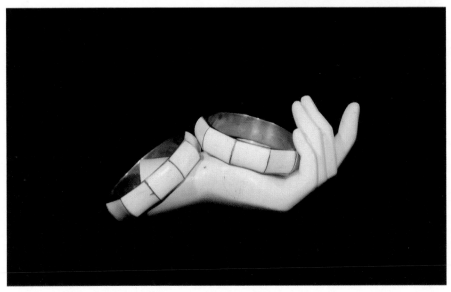

"India" brass with bone-look plastic inlay. 1940s- 50s. $30-40 each

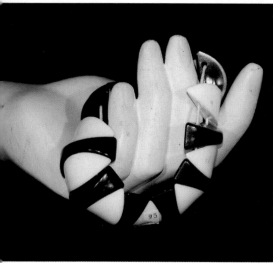

Black and white geometric design stretchable bracelet. 1950s-60s. $15-22

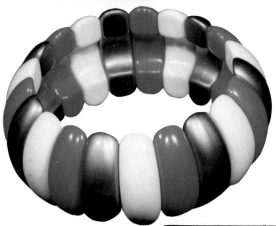

Gold, white and salmon plastic bracelet strung with elastic. 1950s. $30-40

Orange swirl plastic stretch bracelets with gold-tone metal spacers. 1950s-60s. $18-22

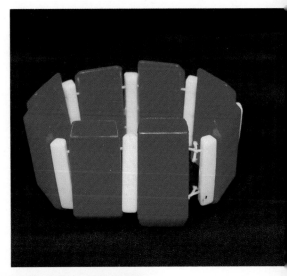

Plastic oblong segments in red and white make up this stretch bracelet. 1960s. $15-20

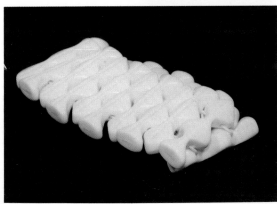

White expandable elastic strung bone-look bracelet. 1960s. $20.00-25

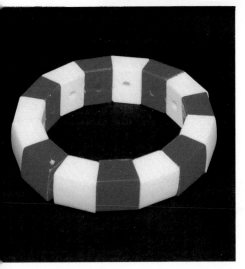

Red and white square cut expandable bracelet. 1970s. $20-30

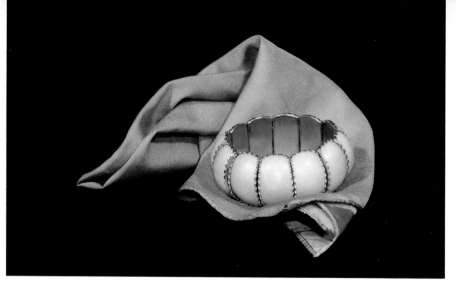

Blue pearlized plastic set in gold-tone metal stretch bracelet. 1940s-50s. $30-35

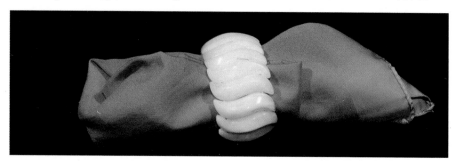

Stretch plastic bracelet with white S-shaped segments. 1980s. $8-12

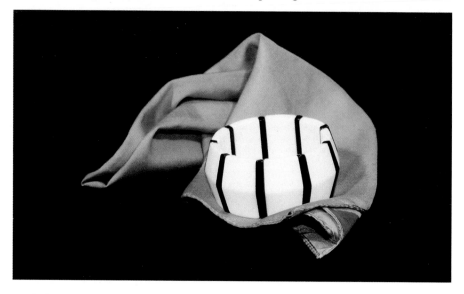

White oblong plastic stretch bracelet with narrow black spacers. 1970s. $15-20

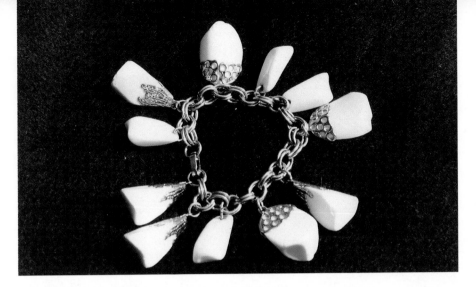

Tear drop design plastic bead bracelet. 1950s. $10-15

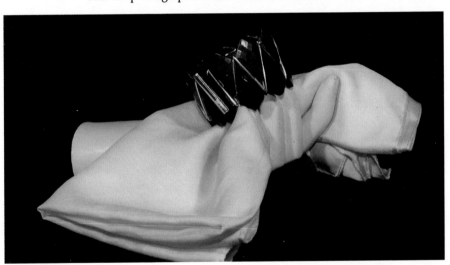

Geometric-shaped plastic with gold colored accents. "Western Germany," 1950s-60s. $20-30

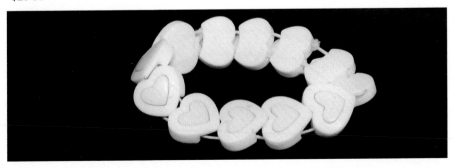

Child's carved heart bracelet, strung on elastic. $1970s. $5-7

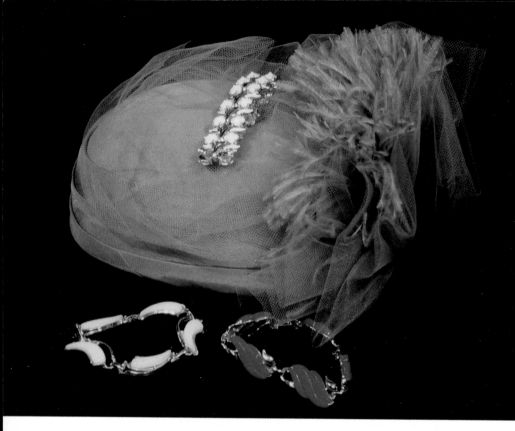

Three gold-tone bracelets with plastic insert beads. 1950s. $8-12 each.

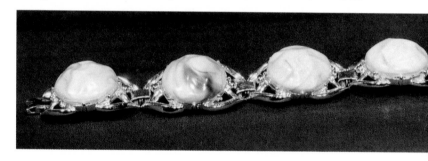

Gold-tone bracelet with plastic turquoise-look stone. 1950s. $25-35

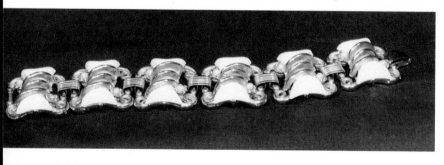

Gold-tone designer bracelet with bone-look plastic inserts. 1950s. $20-30

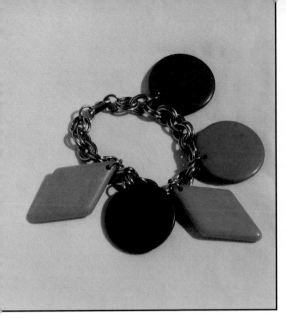

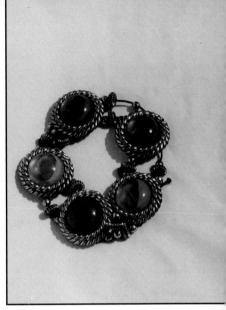

Circles and diamond-shaped plastic
discs on chain bracelet. 1950s. $8-12

Tear drop design plastic bead bracelet.
1950s. $10-15

Varied sizes and shapes of plastic beads on a bracelet. 1940s. $30-40

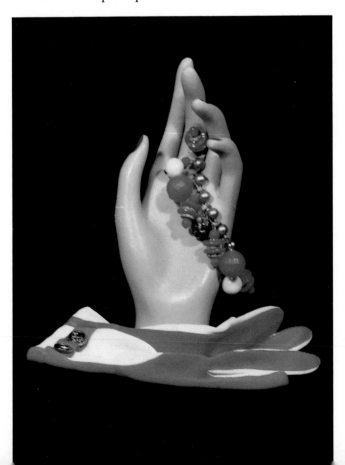

Necklaces

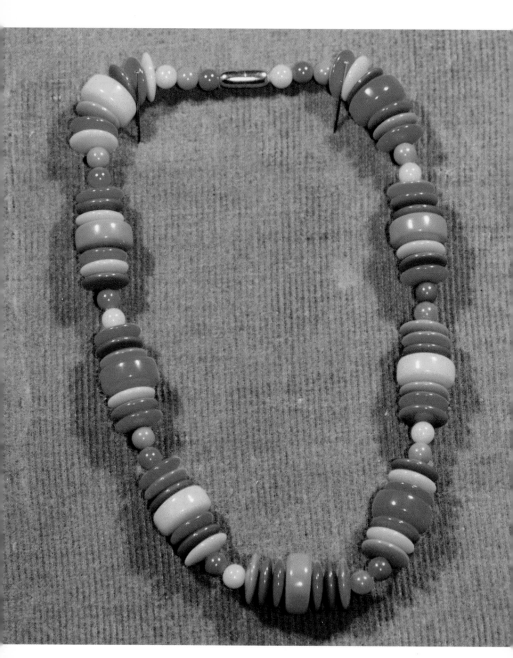

Multi-colored round and flat plastic discs. 1970s- 80s. $12-15

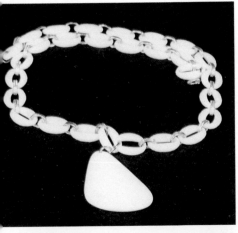

Round plastic chain with plastic disc drop. 1970s. $8-12

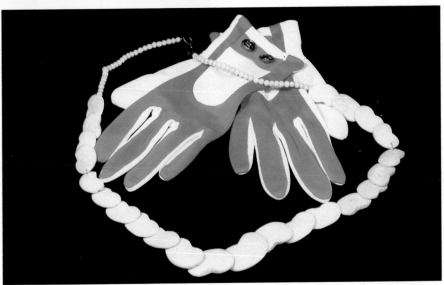

Heart-shaped plastic beads strung on wire with small plastic round beads and hook clasp. 1940s. $15-20

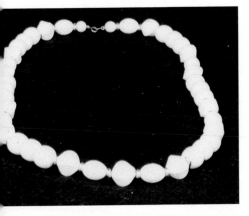

Multi-shaped plastic beads with metal spacers. 1970s. $8-12

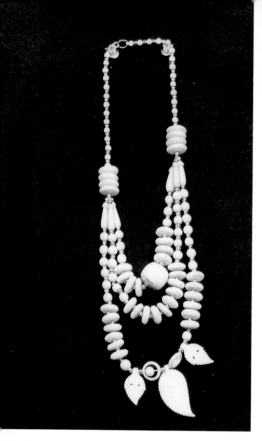

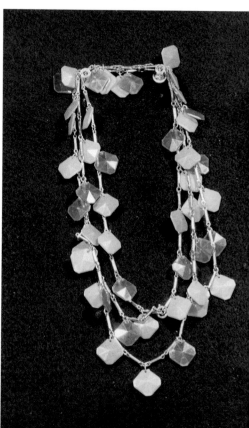

Celluloid necklace with long stick-like beads and round celluloid clasp and beads. Double strung. 1940s-50s. $35-45

Geometrical plastic squares with barrel-like metal links. 1960s. $20-25

Triple strands of textured plastic discs and leaves with silver spacers. 1960s. $45-50

Plastic sea shells with swirl square spacers. "West Germany," 1970s. $15-20

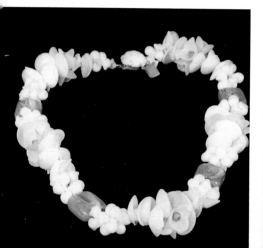

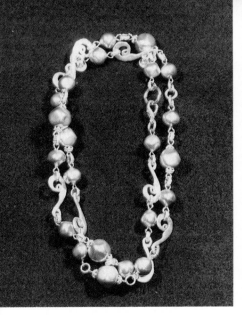

Silver-tone necklace with plastic pearlized bead inserts. 1960s. $8-12

Round white plastic and pink glass beads with silver chain and clasp. 1960s. $8-12

Necklace with plastic pink flowers and green leaves. 1960s. $15-20

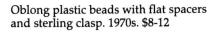

Oblong plastic beads with flat spacers and sterling clasp. 1970s. $8-12

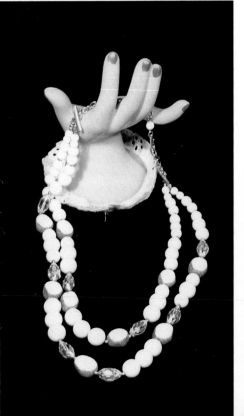

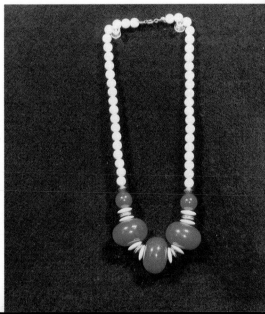

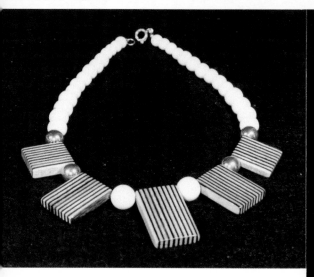

Ivory and gold-tone plastic beads with square laminated wood spacers. 1970s. $15-20

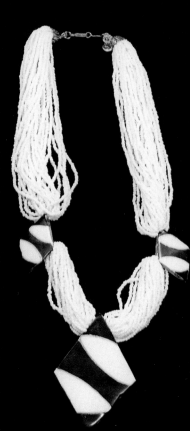

Thirty-two strands of white glass beads with black and white geometric Bakelite and brass drops. 1950s-60s. $40-50

White plastic beads in a variety of sizes and shapes. 1980s. $3-4

Plastic seed-shaped beads with silver spacers. 1960s-70s. $8-12

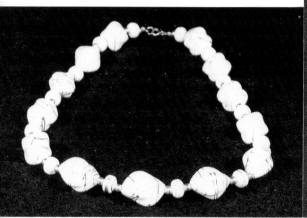

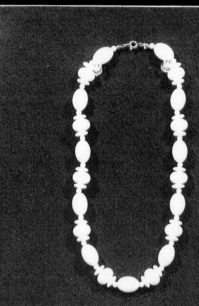

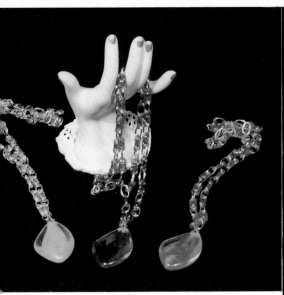

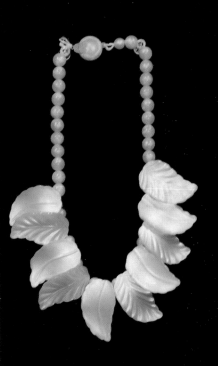

Three plastic chain necklaces with tear drop-shaped center drop beads. 1950s-60s. $6-10

Yellow marbleized lucite beads with lucite leaves. 1940s. $45-55

Light green and mother of pearl beads with pearlized plastic discs. 1970s. $20-30

Pink and white stone textured plastic disc-styled necklace. 1960s. $30-40

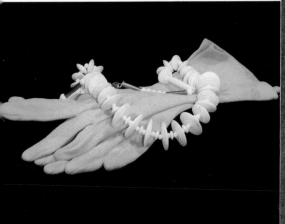

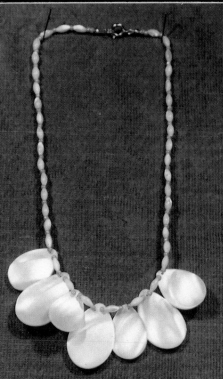

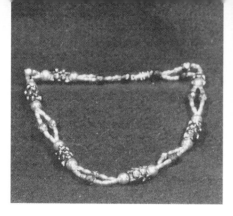

Borealis and gold plastic beads with
barrel clasp. 1960s. $6-8

Flower-shaped disc with multi-colored
plastic beads for petals. 1960s-70s. $8-10

Multi-colored plastic beads with silver
spacers. 1960s. $10-14

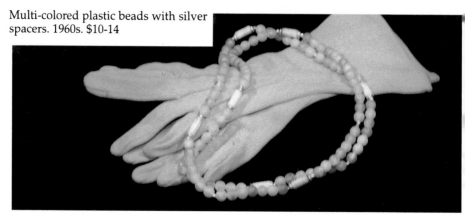

Beaded necklace with pink, pearlized
plastic half circles, individually tied.
1970s. $15-20

Plastic imitation turquoise necklace with
silver spacers. 1980s. $5-8

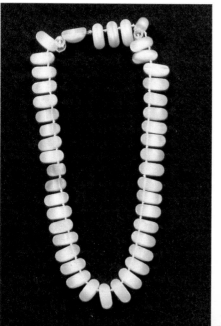

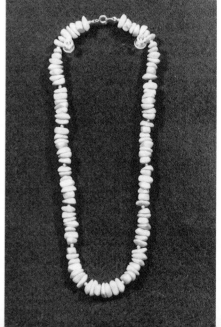

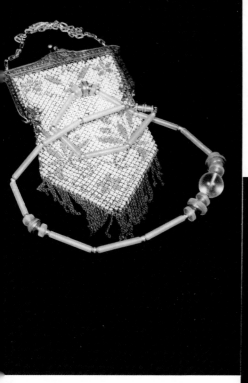

Clear lucite elongated beads with glass spacers and large drop lucite center bead. 1940s-50s. $15-20

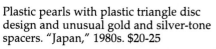

Plastic pearls with plastic triangle disc design and unusual gold and silver-tone spacers. "Japan," 1980s. $20-25

Red plastic "pop" beads. 1950s. $15-20

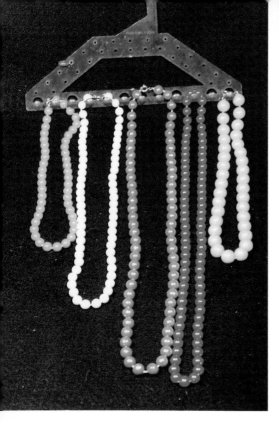

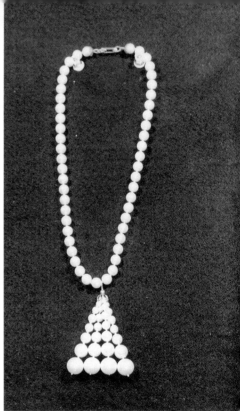

Five single strand necklaces of found plastic beads. 1950s-60s. $4-8 pair

Light pink plastic single strand necklace with four strand tear drops. 1950s. $15-20

Bronze colored plastic beads with gold-tone spacers. "Greece." 1960s. $50-65

Necklace with large round plastic beads. 1980s. $3-4

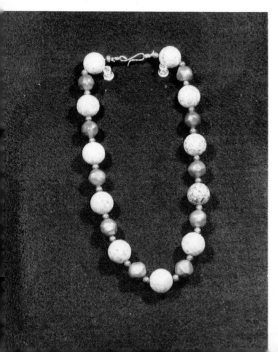

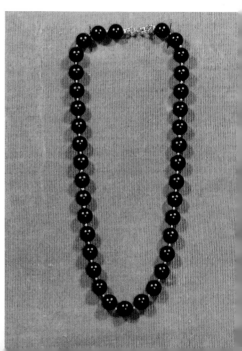

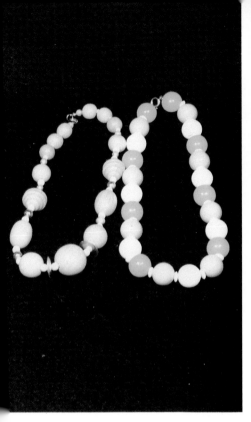

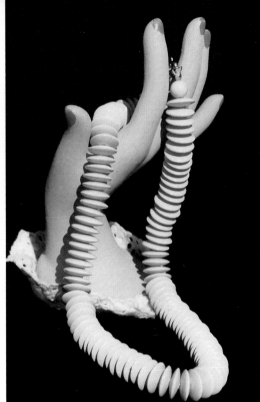

Large wooden and plastic beads with plastic spacers, discs, and silver plastic beads. 1970s. $7-10

Disc-shaped plastic beads strung on waxed string with sterling silver clasp. 1960s. $25-30

Plastic designer necklace on gold wash chain. 1960s-70s. $10-15

Child's necklace with plastic yellow beads and a single drop. 1950s. $20-30

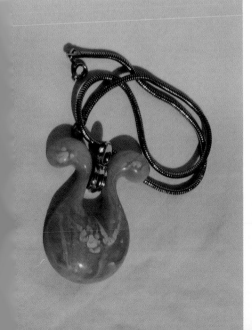

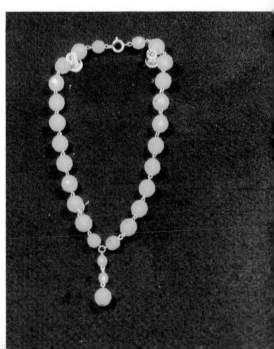

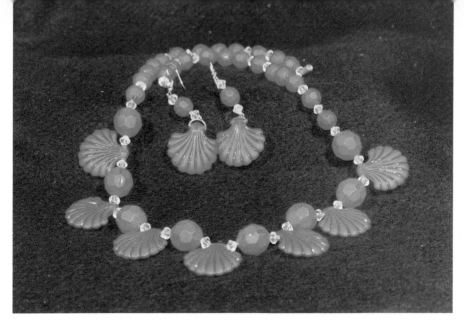

Red plastic shell-look necklace with crystal spacers. 1950s. $30-40

Silver-tone plastic beads and spacers.
1980s. $5-8

Gold-tone frosted beads. 1970s. $7-10

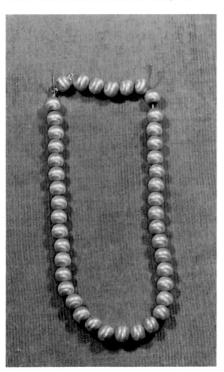

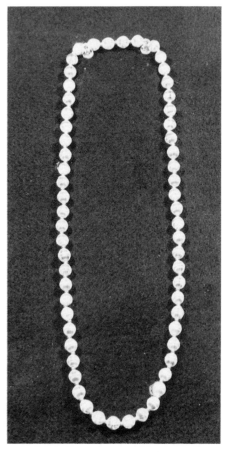

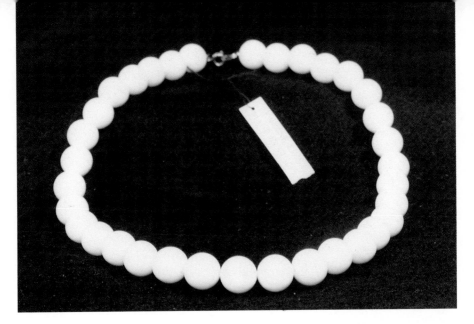

White lucite beaded necklace. Marked "Ahbra Cale Collection, China." 1970s-80s. $18-25

Grey plastic beads with hook clasp. 1960s. $5-7

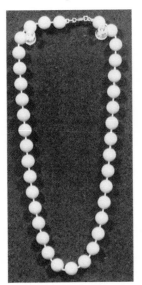

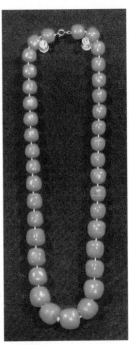

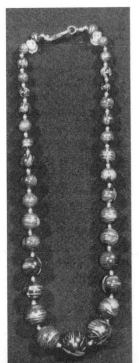

Salmon colored plastic beads with gold-tone clasp. 1970s. $10-15

Molded green plastic beads with gold swirls and gold spacers. Large lobster claw clasp. 1970s. $15-20

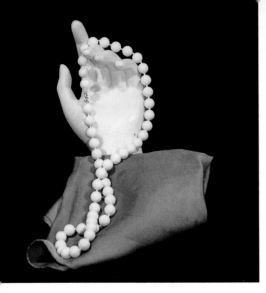

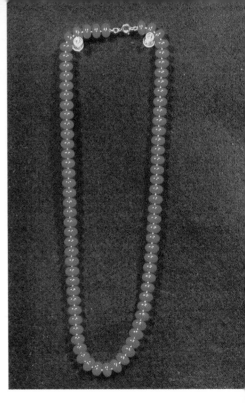

Light blue plastic single strand beads
with waxed string. 1980s. $8-10

Red plastic flattened bead necklace.
1980s. $4-5

Lavender colored plastic beads with
white and gold colored plastic spacers.
1950s-60s. $10-15

Blue plastic single strand necklace.
1980s. $2-3

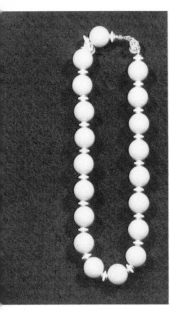

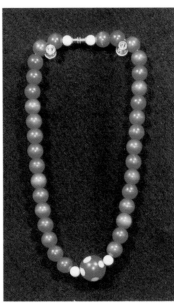

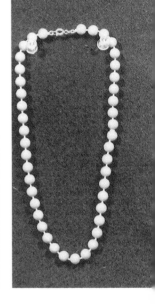

Red and white pearlized beads sur-
round a large red plastic center with
white polka dots. 1960s. $8-10

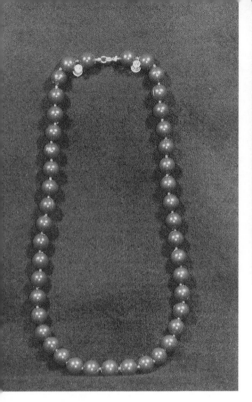

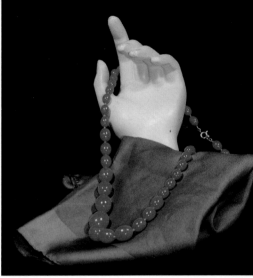

Red ovoid plastic beads with gold-tone hook. 1980s. $8-12

Blue single strand necklace with plastic beads with hook clasp. 1960s. $5-7

Tortoise shell beads with gold-tone spacers. 1950s-60s. $15-20

Frosted plastic faceted "Moonstone" beads and gold-tone spacers. 1940s. $40-50

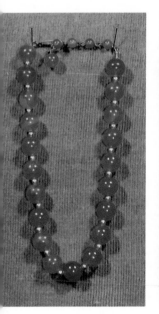

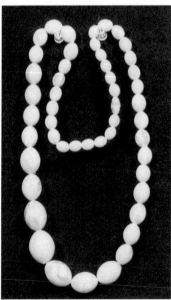

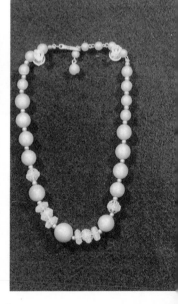

Pink plastic swirl beads with graduated sizes and unusual gold-tone closure. 1960s. $20-25

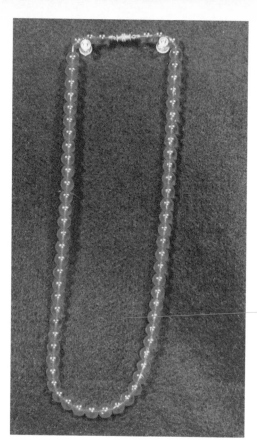

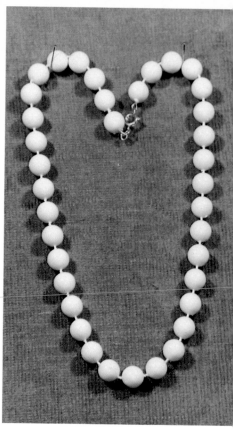

Clear red plastic beads with brass barrel clasp. 1940s-50s. $18-25

Round plastic beads. 1980s. $6-10

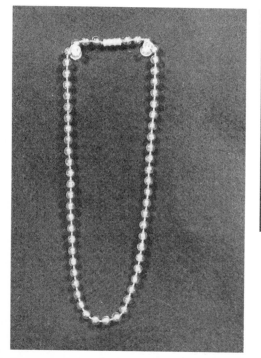

Plastic beads and spacers and drop hook fastener. 1960s. $8-10

Green clear plastic beads with barrel closure. 1980s. $3-4

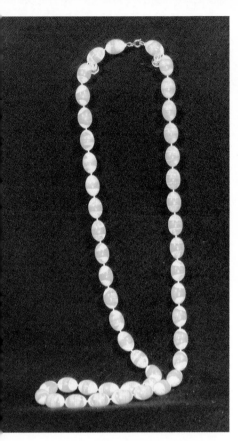

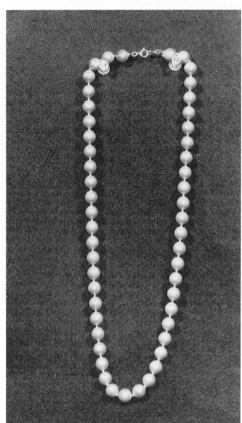

Oblong yellow and white swirl plastic
beads with waxed string. 1980s. $8-12

Purple plastic pearlized beads with
gold-tone closure. 1970s. $3-4

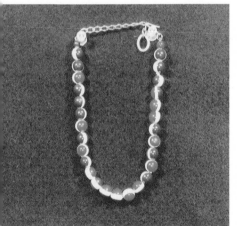

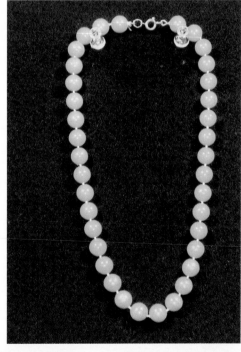

Red, white, and blue plastic beads with
swirl designs. "Hong Kong." 1970s. $5-7

Neon yellow plastic beads on waxed
string. 1980s. $5-8

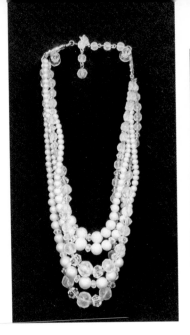

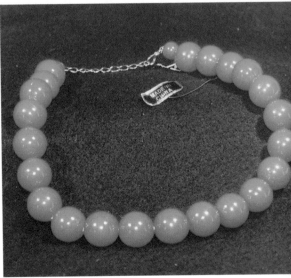

Five strand necklace with opaque plastic beads, with crystal beads and spacers. "Japan" 1940s-50s. $40-50

Large red lucite beaded necklace. Marked "China." 1970s. $20-30

Five strand necklace with round plastic beads and small glass spacers. 1950s. $15-20

Plastic marbleized beads on braided wire chain. 1940s. $30.00-35

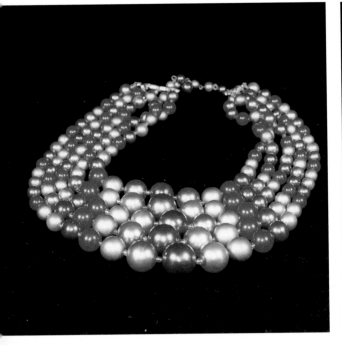

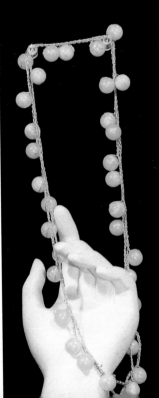

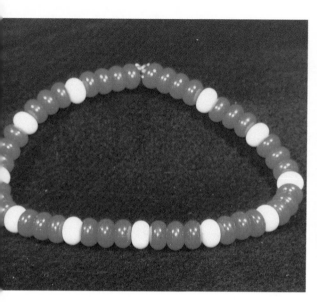

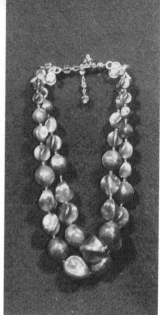

Red and white plastic bead necklace. 1970s-80s. $6-10

Variously shaped plastic swirl beads fill this double strand necklace. 1970s-80s. $8-12

Long single strand necklaces, one with pink plastic beads and the other with yellow. 1980s. $ 5-8 each

Four strands of round plastic beads and glass spacers. 1970s. $7-10

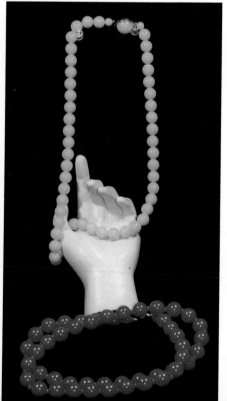

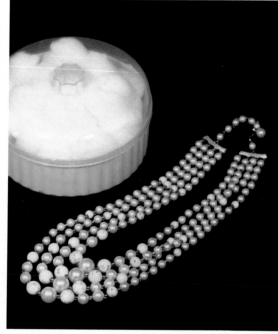

75

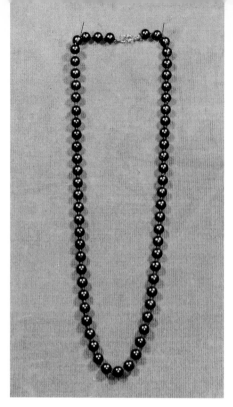

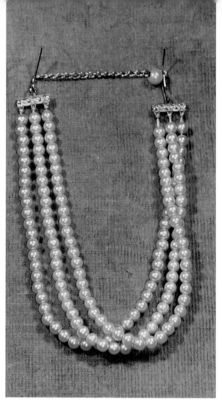

Long black plastic bead necklace on waxed string. 1980s. $3-4

Three strand plastic pearl necklace. 1950s. $15-22

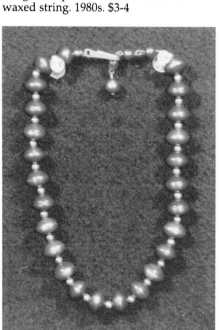

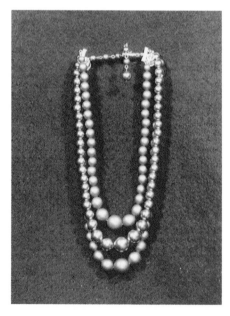

Moonstone oval beads with gold-tone spacers. 1950s. $40-50

Grey pearlized plastic beads on a triple strand necklace. Hook clasp. 1950s. $12-18

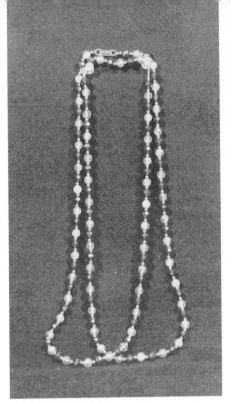

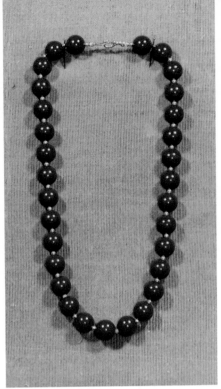

Light and dark blue faceted plastic beads with brass closure and spacers. 1950s. $20-30

Dark blue round plastic beads with metal spacers. 1950s. $20-30

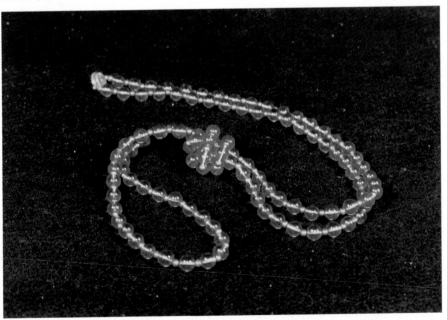

Round plastic beads with round brass spacers. 1930s-40s. $30-40

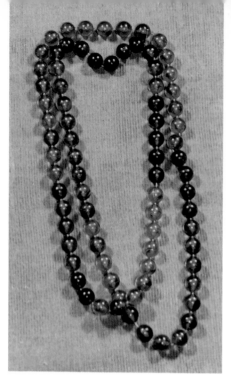

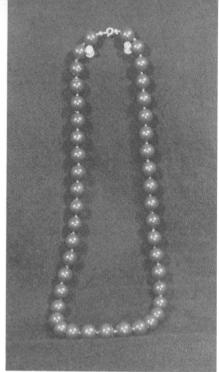

Single strand of tortoise shell plastic
beads and spacers. 1980s. $5-7

Plastic beads with plastic spacers and
gold-tone clasp. 1970s. $8-12

Double strand necklace with black
faceted plastic beads of various sizes
and glass spacers. 1970s. $12-15

Black beads and white disc-shaped
spaces bedeck this plastic necklace.
1980s. $8-12

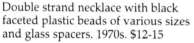

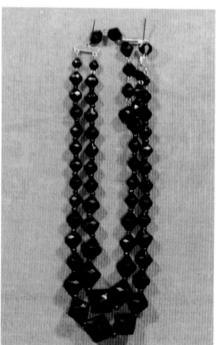

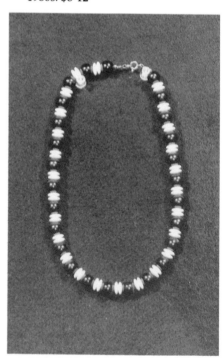

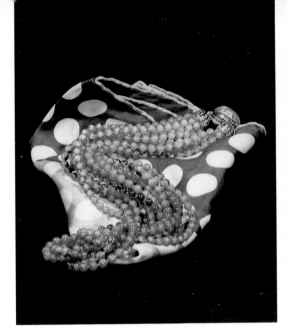

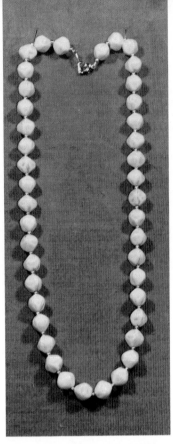

Seven strand necklace with tortoise shell-look beads and matching clasp. 1970s. $10-15

Clear faceted crystal-look beads with no clasp. 1980s. $8-10

Plastic ivory colored faceted beads with gold spacers. Note the heart-shaped clasp. 1960s. $20-25

Round pink plastic beads with gold-tone hook. 1960s. $8-10

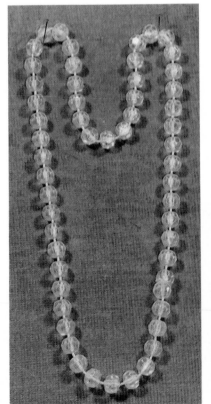

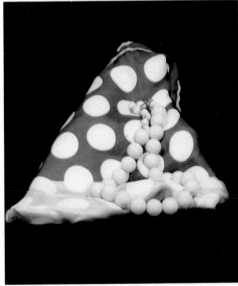

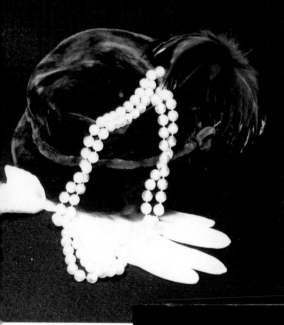

Pearlized lavender plastic beads strung on waxed thread. 1960s. $10-14

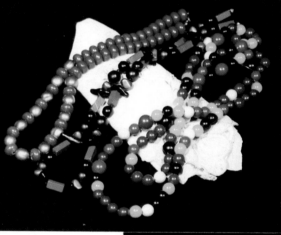

Round plastic beaded necklaces with no spacers. 1960s. $10-15 each.

White plastic beads of various shapes with crystal spacer beads. 1950s-60s. $15-20

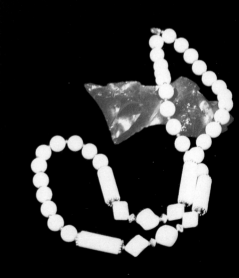

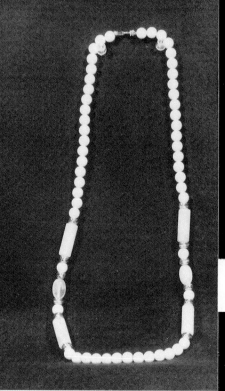

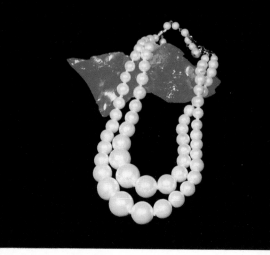

Double strand necklace with plastic pearls on waxed string. 1960s. $10-14

Ivory colored plastic beads in various sizes. 1970s-80s. $10-13

Triple strand necklace with round graduated plastic beads. 1980s. $5-8

Pink plastic with clear plastic spacer beads. Large bead on clasp. "Hong Kong," 1960s. $10-15

Napier red plastic necklace with large red beads and gold-toned connector beads. 1980s. $25-35

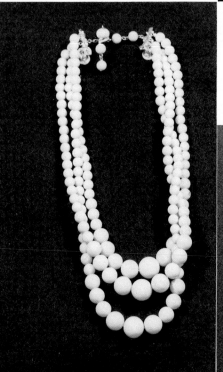

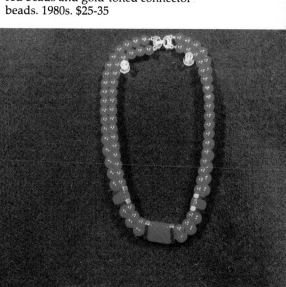

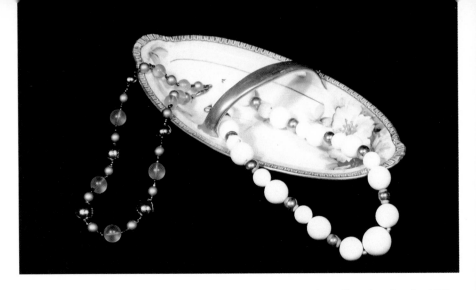

Left: white plastic beads with gold-tone glass spacers and smaller glass beads. 1950s. $8-12. Right: Silver and tan plastic beads with silver spacers. 1950s. $8-12

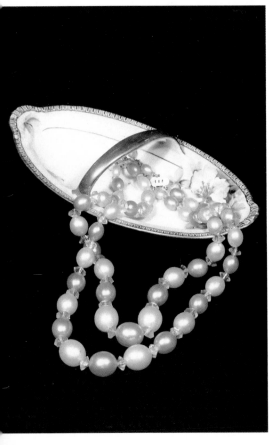

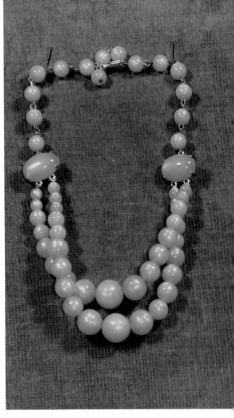

Round plastic tan beads with glass spacers. 1960s. $8-12

Orange double strand necklace with "Moonstone" round beads and large bead insets. 1960s. $25-35

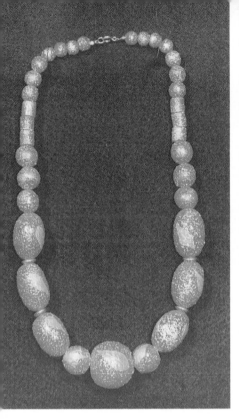

Red textured plastic beads with leaf design. 1960s. $12-16

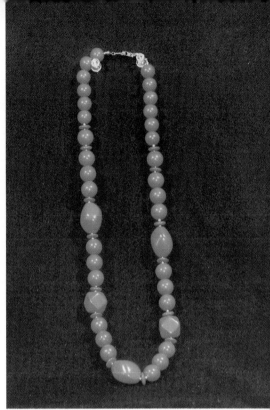

Red plastic beaded necklace with diamond-shaped spacers and sterling clasp. 1970s. $15-20

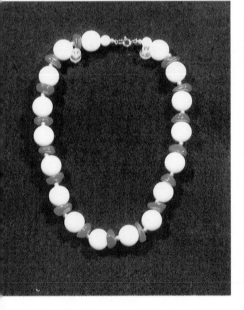

Red discs and white round beads with metal spacers. 1980s. $5-7

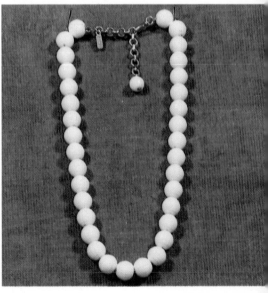

"Monet" necklace with faceted round white plastic beads. 1940s. $25-35

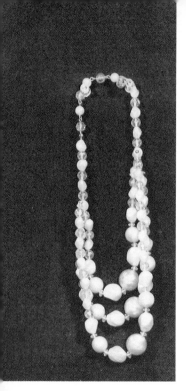

Green plastic beads with jade-look centerpiece and gold-tone spacers. 1980s. $15-20

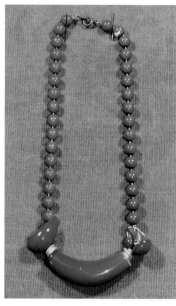

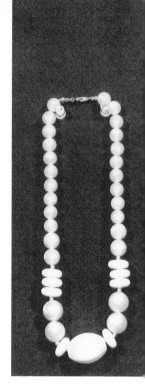

Solid pink and swirl plastic beaded double necklace with gold spacers. 1970s. $10-15

Frosted plastic swirl beads with plastic spacers. 1950s. $20-25

Multi-colored plastic beads with disc-shaped spacers. Sterling clasp. 1960s. $15-20

Yellow and white plastic double strand necklace. 1950s. $15-20

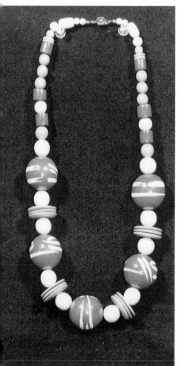

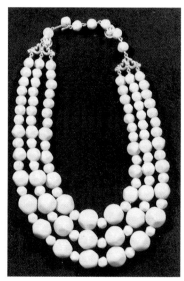

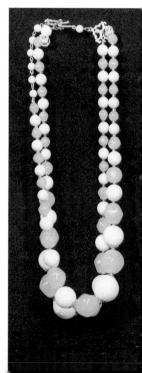

Triple strand necklace with plastic hexagon-shaped beads and spacers. 1950s. $8-12

84

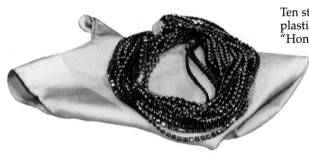

Ten strand necklace of light weight plastic beads with gold-tone clasp. "Hong Kong". 1970s. $10-15

Five strand necklace with various sizes of plastic beads, a bead clasp, and gold-tone hook. 1960s. $10-15

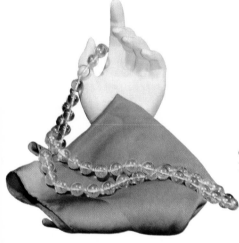

Clear individually tied plastic beads. 1950s. $15-20

Five strand necklace with plastic round beads in two shades of blue, and a gold-tone hook. 1960s. $15-20.

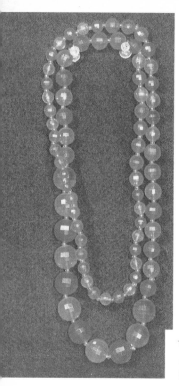

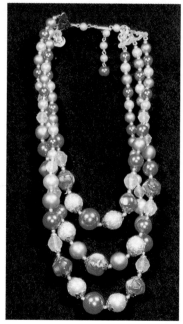

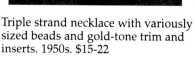

Triple strand necklace with variously sized beads and gold-tone trim and inserts. 1950s. $15-22

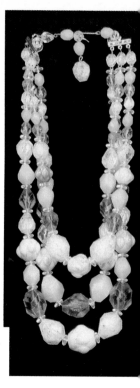

Multi-colored long strand plastic necklace with faceted beads. 1950s. $15-19

Triple strand faceted plastic beads with glass spacers. "Western Germany". 1950s. $20-30

Unusual faceted plastic spacers between the cork beads of this three strand necklace. 1940s. $20-25

Orange borealis plastic double strand necklace. "Hong Kong." 1950s. $12-15

Red and gold plastic beads with large wavy disc spacers. "Hong Kong". 1960s. $15-20

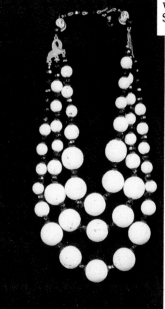

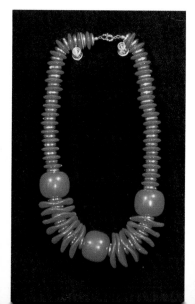

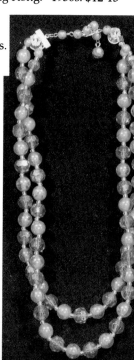

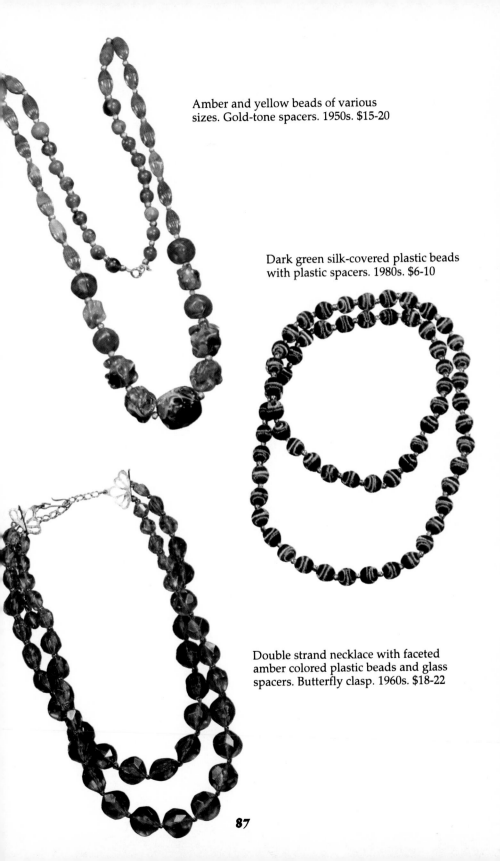

Amber and yellow beads of various
sizes. Gold-tone spacers. 1950s. $15-20

Dark green silk-covered plastic beads
with plastic spacers. 1980s. $6-10

Double strand necklace with faceted
amber colored plastic beads and glass
spacers. Butterfly clasp. 1960s. $18-22

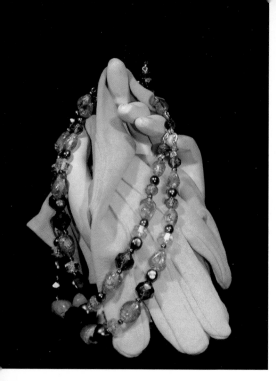

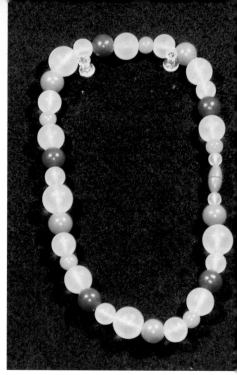

Amber and green plastic beads with bronze colored spacer beads make up this double strand necklace. "West Germany," 1950s. $20-25

Plastic frosted multi-colored round beads. 1970s. $5-8

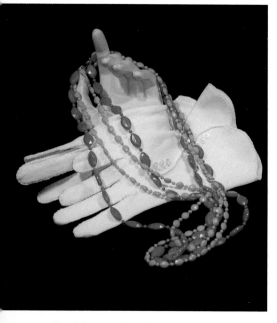

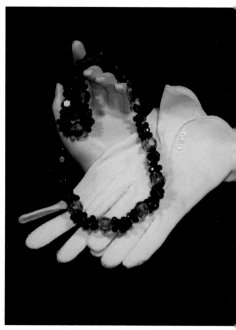

Double strand necklace with orange and gold faceted beads. 1970s. $8-10

Necklace with multi-shaped gold and black plastic beads. "Western Germany" 1960s. $25-35

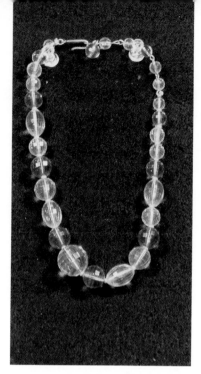

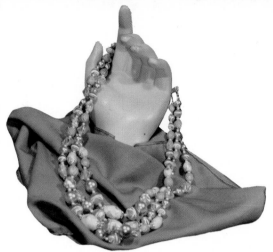

Triple strand necklace with pearlized swirl plastic beads and silver findings. "Japan". 1950s. $10-15

Clear plastic faceted beads. 1970s. $8-12

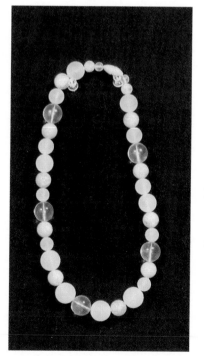

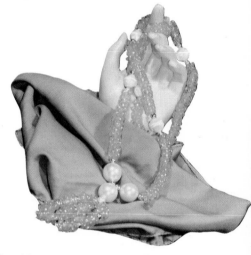

Yellow fitted beads with white round plastic beads and hanging center tassel. 1970s. $15-20

Long plastic beads with white plastic flower center. 1970s. $20-25

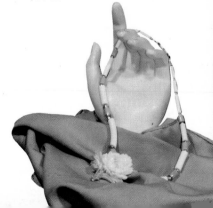

Frosted swirl clear plastic beads with unusual matching clasps. 1940s. $15-20

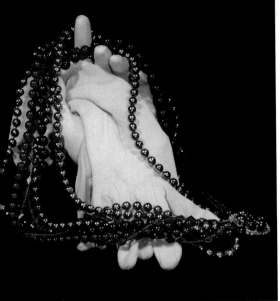

Opposite page:

Double strand necklace with amber colored bead with silver spacers. "West Germany," 1950s. $20-30

Seven stranded necklace with blue plastic multi-shaped beads and a beaded clasp. 1950s. $25-35

Varied sizes of plastic beads with glass spacers. 1960s. $12-15

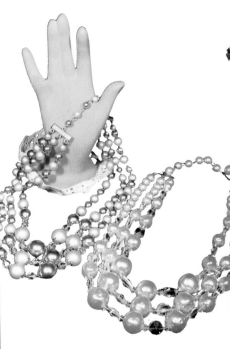

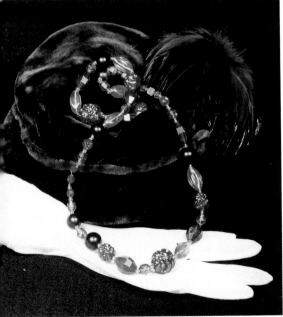

Two necklaces with triple strands of plastic pearlized beads and crystal spacers. 1960s. $12-15 pair.

Opposite page:

Round pearlized plastic beads with cobalt blue square glass beads and round blue spacers. 1950s. $15-20

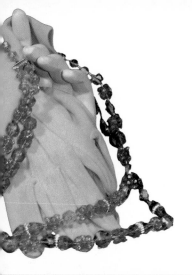

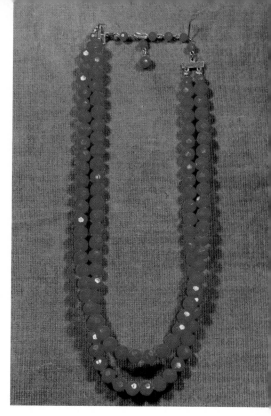

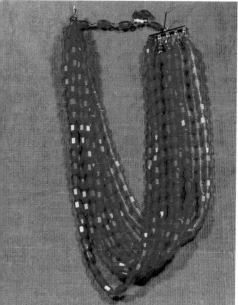

Double stranded necklace with plastic faceted beads. "Hong Kong." 1960s. $8-12

Ten stranded necklace of plastic faceted beads. "West Germany," 1950s. $10-14

Triple strand necklace with plastic faceted red beads. 1950s. $15-20

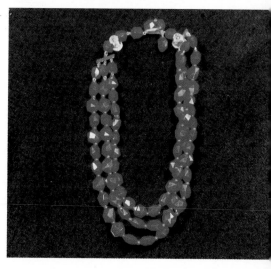

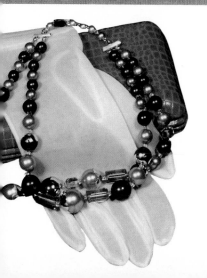

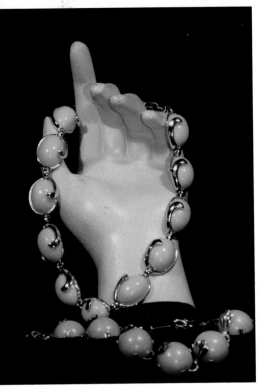

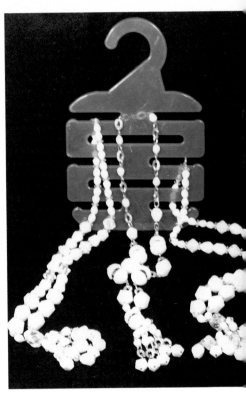

Two beaded necklaces with plastic beads in metal frames. The blue beads are round and the pink oval. 1950s. $14-20 each.

Three pair of plastic necklaces with plastic front drops. 1950s. $8-12 each.

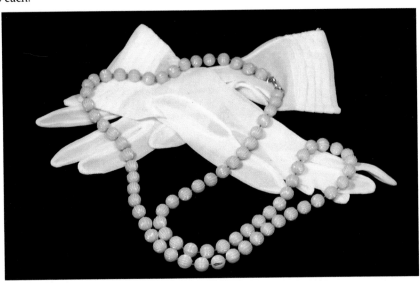

Molded design plastic beads on waxed string. 1960s. "Sara Cov". $8-12

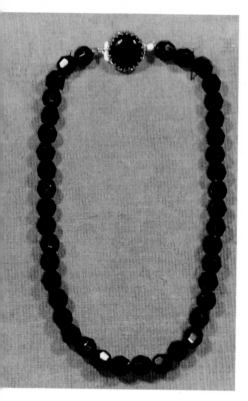
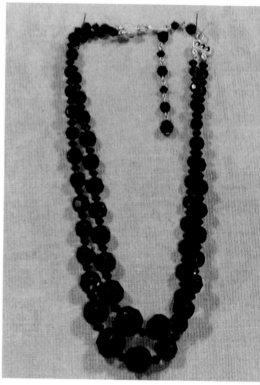

Black faceted plastic beads with large
round bead as a clasp. 1950s. $15-20

Double strand necklace with faceted
plastic beads of various sizes. 1940s.
$35-40

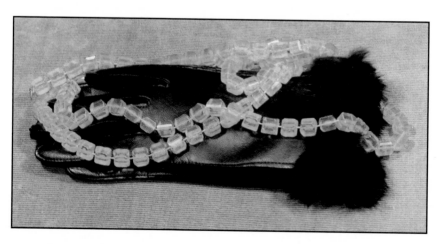

Long necklace with yellow square plastic block beads. 1960s. $10-15

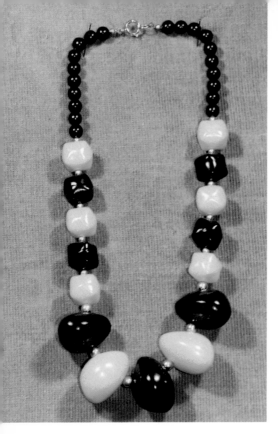

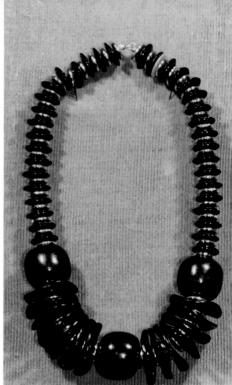

Black and yellow plastic beads with gold-tone spacer beads. 1970s. $12-16

Black and gold flat plastic beads, with large wavy spacers and large round decorative beads at the bottom. "Hong Kong". 1960s. $18-22

Black discs and round beads make up the design of this necklace. 1960s. $16-22

Plastic discs and round beads with gold-tone decorative discs. 1980s. $10-15

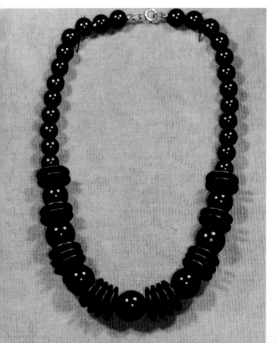

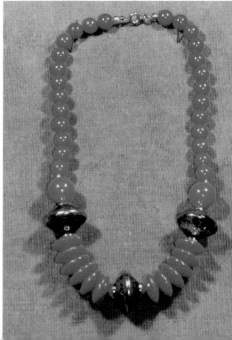

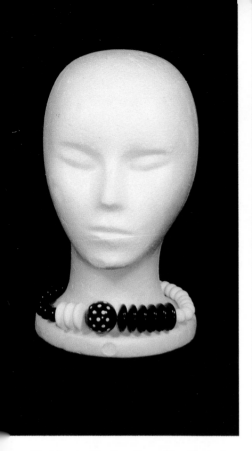

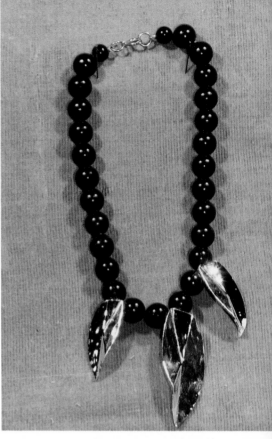

Necklace with disc-shaped beads and polka dot round bead in center. 1970s. $12-16

Black plastic beads with silver geometric drops and inlaid plastic leaves. 1980s. $10-14

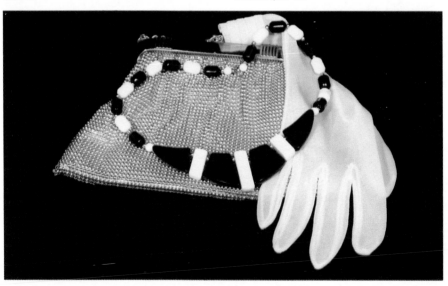

Black and white plastic designer necklace. 1960s-70s. $15-20

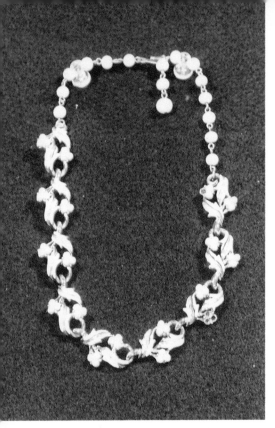

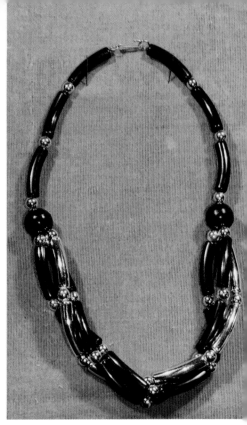

"Coro" necklace with leaf-shaped white enamel and plastic inserts. 1960s. $10-15.

Silver and plastic long beads with woven-look triple strands hanging at the front. 1980s. $15-20

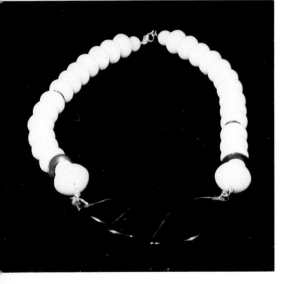

Plastic inlaid oval beads in gold-tone necklace. 1950s. $20-30

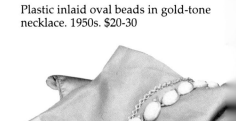

Black and white lucite beads with shaped center piece. 1970s. $15-20

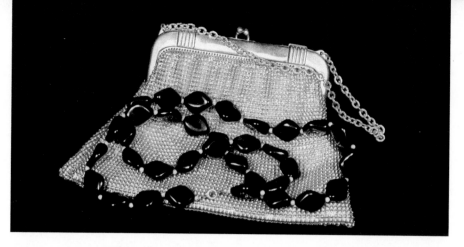

Black plastic diamond cut beads and spacers. 1950s. $20-25

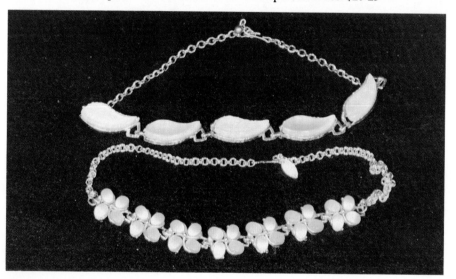

Gold-tone necklaces with plastic trim inserts. 1950s. $10-15

"Coro" necklace with s-shaped beads of plastic set in silver-tone metal. 1950s. $20-25

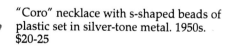

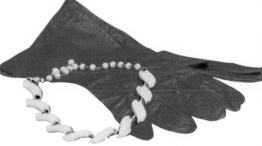

"Trifari" necklace segments of white plastic on silver-tone metal backs. 1950s. $35-45

Sets

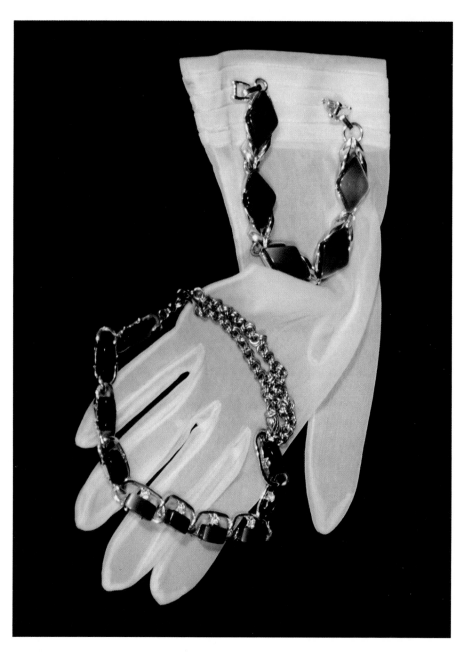

Silver on plastic necklace and bracelet with plastic silver grey stones. 1950s. $20-25

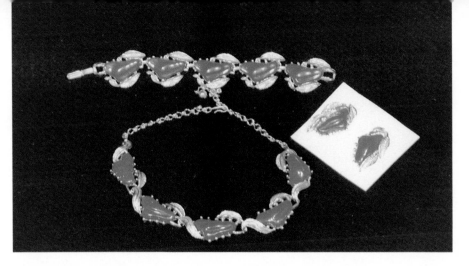

Red stone-look plastic inserts in gold frames on this bracelet, necklace and clip-on earrings set. 1950s. $35-45

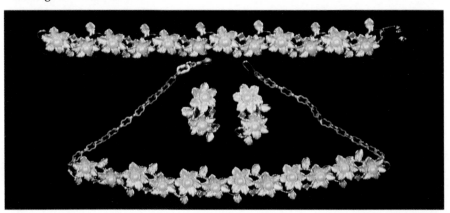

Silver-tone metal frame with plastic pearls and rhinestones. Necklace, bracelet and clip-on earrings. 1960s. $40-50

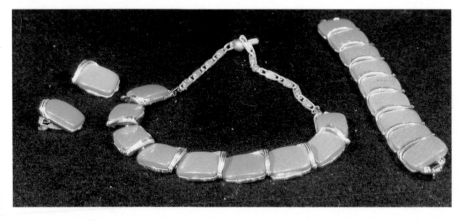

"Lisner" bracelet, necklace and earring with plastic wafers in gold-tone settings. 1950s. $30-40

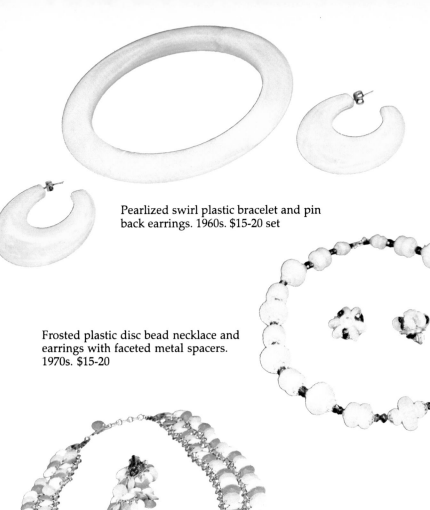

Pearlized swirl plastic bracelet and pin back earrings. 1960s. $15-20 set

Frosted plastic disc bead necklace and earrings with faceted metal spacers. 1970s. $15-20

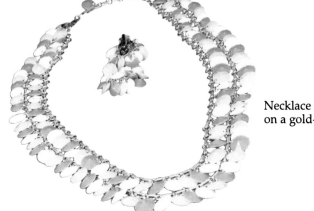

Necklace and earrings with plastic discs on a gold-tone chain. 1950s. $25-35

Round plastic beads, expandable bracelet and clip-on earrings. 1950s-60s. $35-45

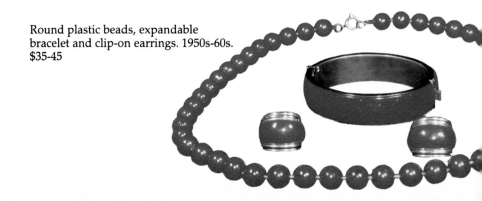

Metal lace-look leaves and plastic beads strung on wire flowers with rhinestone centers. Pin and clip-on earrings. 1940s-50s. $30-40

Gold-tone ribbon-look necklace and bracelet with white plastic inserts. 1960s. $20-30

Gold-look frame and plastic insert bows. Bracelet and earrings. 1960s. $15-20

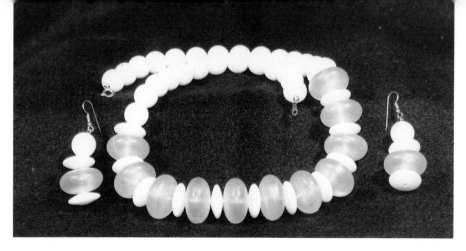

Lavender and white plastic necklace and earrings with flat plastic spacers. 1970s. $12-16

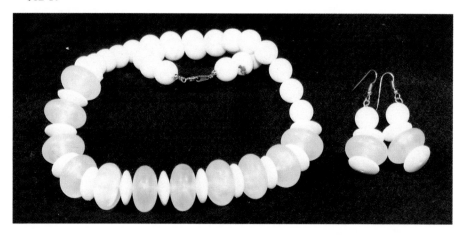

Pink and white plastic necklace and earrings with flat plastic spacers. 1970s. $12-16

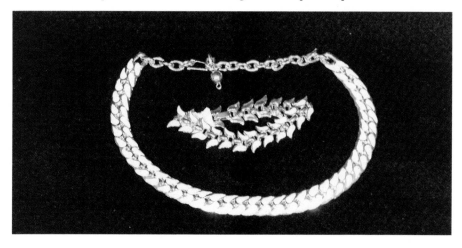

Inlaid plastic on gold-look chain, necklace and bracelet. 1960s. $20-30

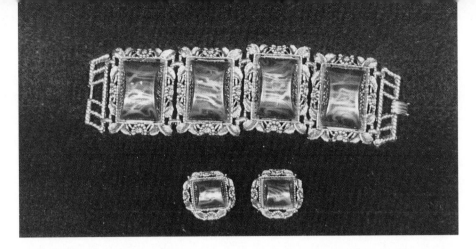

Plastic silver bracelet and clip-on earrings with large plastic stones. 1960s. $25-30

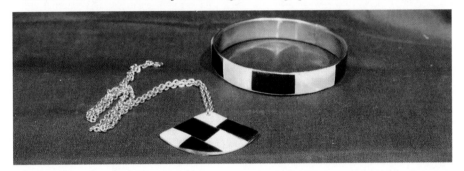

Black and white plastic inserts on silver frame bracelet. Matching necklace. 1960s-70s. $45-55 set.

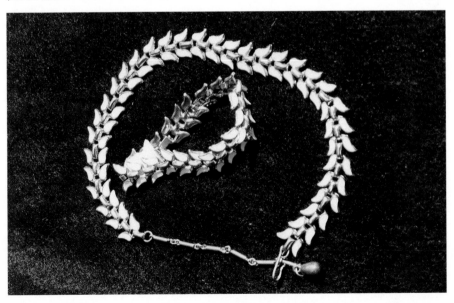

Necklace and bracelet of plastic inlaid on metal frame. 1950s. $20-30 set

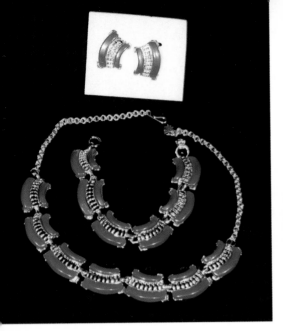

Gold-tone frames with red plastic
inserts make up the segments of these
clip-on earrings, necklace and bracelet.
1950s. $30-40

Copper chain necklace, clip-on earrings
and bracelet with copper-tone sparkle
plastic inserts. 1950s. $30-40

Silver necklace, clip-on earrings, and
bracelet with black plastic inserts. 1960s.
$30-40

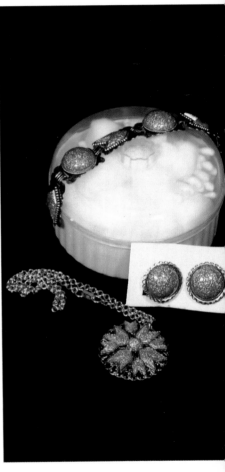

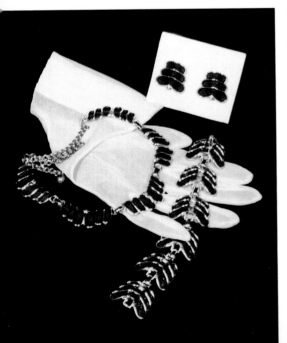

Pins

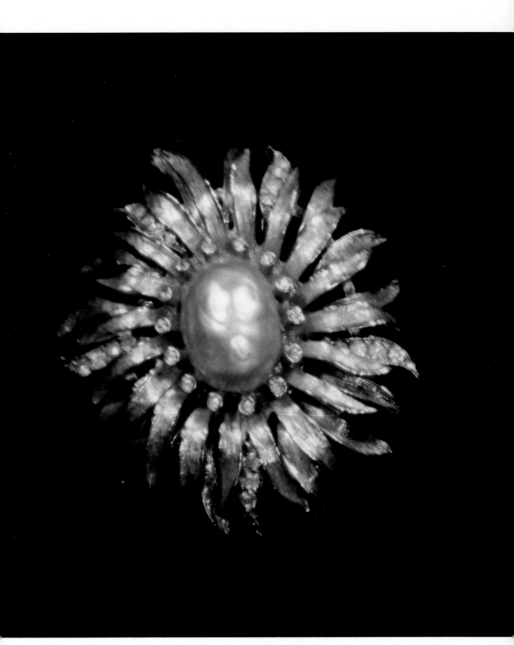

Flower-shaped metal broach with rhinestone trim and plastic pearl center. 1940s.
$6-10

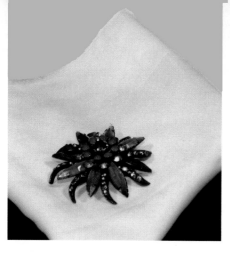

Multi-colored rhinestone broach with plastic petals. 1940s. $30-40

Frosted pink plastic flower with imitation pearl center. 1950s. $12-16

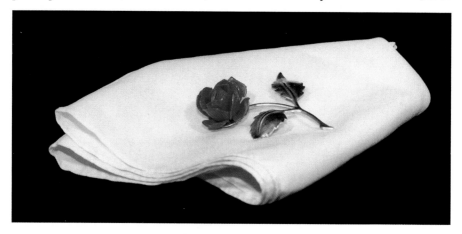

Plastic rose pin with red petals and gold-tone pin. 1960s. $8-11

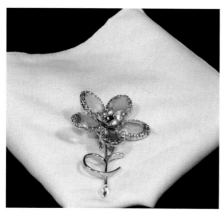 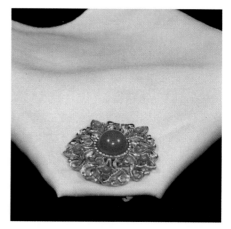

Flower pin with large green plastic petals and green rhinestone center 1940s. $30-40

Gold-tone sun-shaped pin with large red plastic center bead. 1950s. $12-16

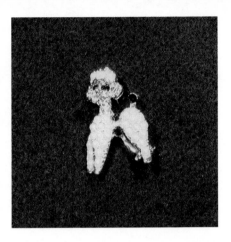 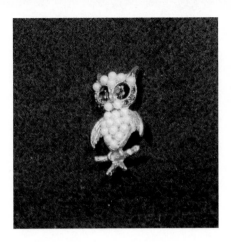

Poodle pin with plastic pearls on head and body and rhinestone eyes with metal base. 1-1/2". 1950s. $15-20.

Owl pin with plastic pearls trim and rhinestone eyes on metal frame. 1". 1950s. $12-15

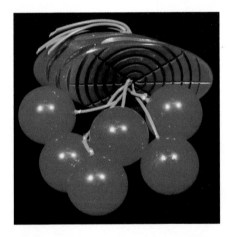

Bakelite cherry cluster pin. 1940s. $25-35

Gold-tone broach with large plastic pearl in center. 1950s. $6-10

Metal frame retro design pin with rhinestone in center. 1940s. $8-12

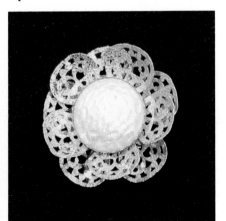

Rings

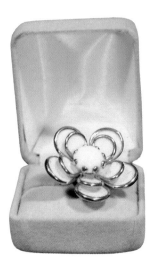

Adjustable flower ring from Vogue.
Plastic leaves. 1960s. $60-70

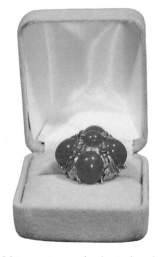

Gold-tone ring with plastic beads from
Coro. 1970s. $45-50

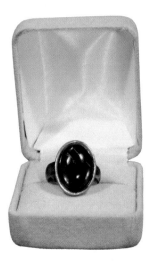

Aluminum ring with plastic "mood"
stone. 1970s. $15-20

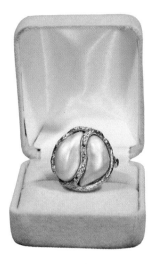

Gold-tone ring with plastic pearlized
stone. "Baroque." 1960s-70s. $100-125

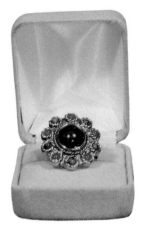

Adjustable ring from Sara Coventry. Plastic inserted beads. 1970s. $35-40

Blue pearlized plastic ring. 1950s. $10-15

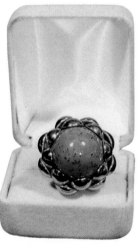

Gold-tone ring with plastic "turquoise-look" stone by Napier. 1970s. $75-100

Buckles

Plastic belt buckles. "Taiwan," 1980s. $2-3 each

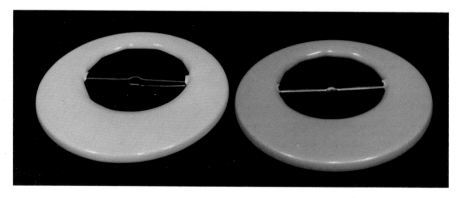

Plastic belt buckles. 1950s. $4-6 each

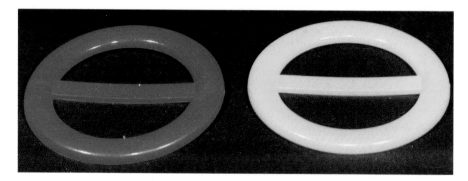

Red and blue plastic belt buckles. 1960s. $5-6 each

Plastic belt buckle with silver indents. 1960s. $8-10

Round white plastic buckle with rhinestones. "Taiwan," 1970s-80s. $5-7

Round frosted plastic buckle with red highlights and red plastic stone. 1960s. $7-9

White plastic heart-shaped belt buckle. 1980s. $3-4

Plastic inserts in pot metal framed belt buckle. 1960s. $5-8

Plastic belt buckle. 1950s. $4-6

Tortoise shell hair clip. Geometric shape. "Made in France," 1950s-60s. $12-16

Tortoise shell and rhinestone leaf shaped hat pin with screw-on tip. 1930s-40s. $35-45

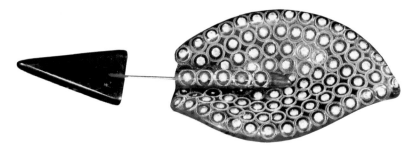

Tortoise shell and rhinestone leaf shaped hat pin with screw-on tip. 1930s-40s. $35-45

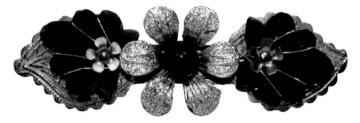

Silver colored metal floral clip with plastic petals. "Korea," 1960s-70s. $8-12

Plastic hair clip with glitter and gold colored metal discs. 1950s-60s. $15-20

Black plastic with gold trim hair clip. "Made in France," 1970s. $5-7

Gold-tone metal glove clip with plastic pearl effect. 1950s. $12-16

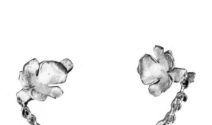

Gold-tone sweater guard with plastic pearl in center of flower. 1950s. $12-15

Shoe clips with burlap base and plastic vegetables. 1960s. $10-15

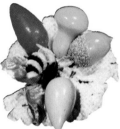

Plastic heart clips on this sweater guard. 1950s. $10-14

Plastic beaded shoe clips. 1950s. $12-16

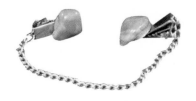

Sweater guard with plastic stones on its clips. 1950s. $10-14

Sunglasses

Square plastic sun glasses with pink and white check pattern. 1960s-70s. $20-25

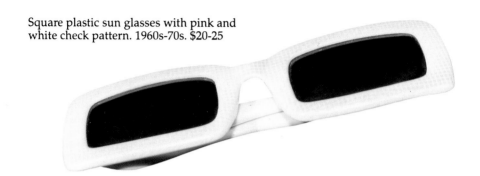

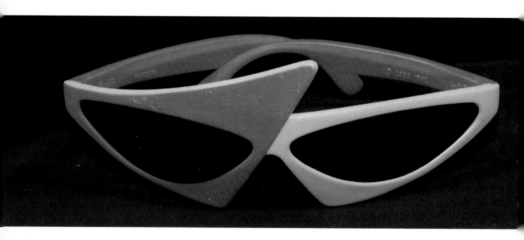

Cat eye mod glasses in yellow and red plastic. 1960s. $30-40

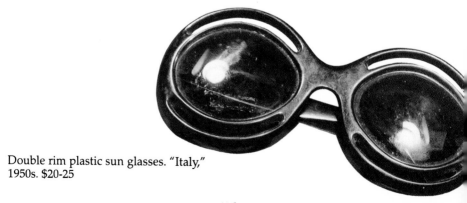

Double rim plastic sun glasses. "Italy," 1950s. $20-25

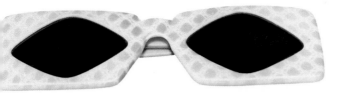

Square sun glasses with diamond shaped inserts and pink checkered design. 1950s. $18-22

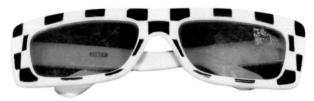

Black and white checkered sun glasses. 1950s-60s. $15-20

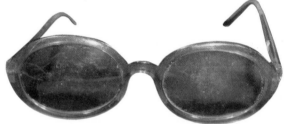

Green transparent plastic sun glasses. 1960s-70s. $8-12

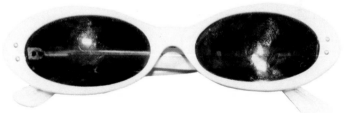

Cat's eye plastic sun glasses with rhinestone inserts. 1960s. $15-20

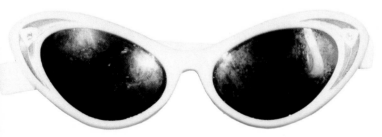

Designer plastic sun glasses. 1960s. $12-15

Purses

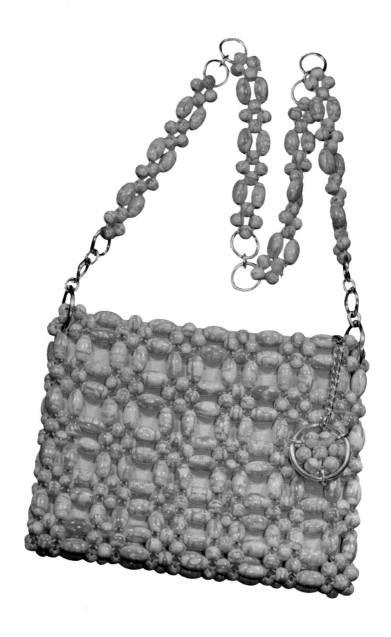

Plastic beaded purse lined in plastic. 1950s. $25-35

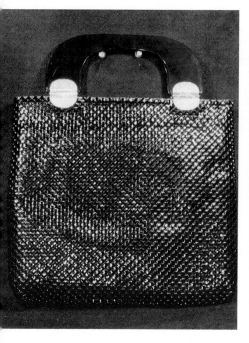

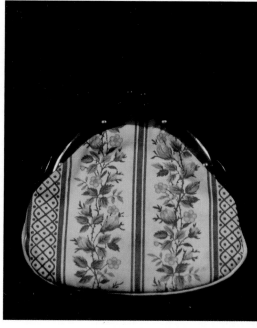

Plastic handled purse with metal beads. 1950s. $20-30

Needle point handbag with tortoise shell plastic handle. 1960s. $20-30

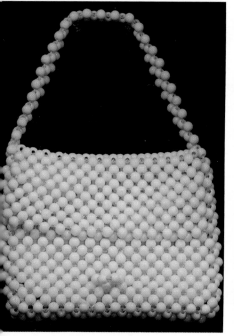

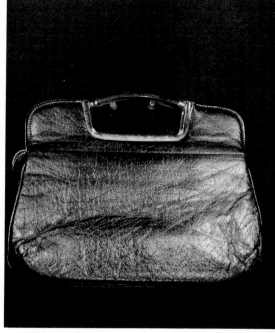

Large beads on plastic beaded purse. 1950s. $20-25

Leather handbag with plastic handle. 1960s. $15-20

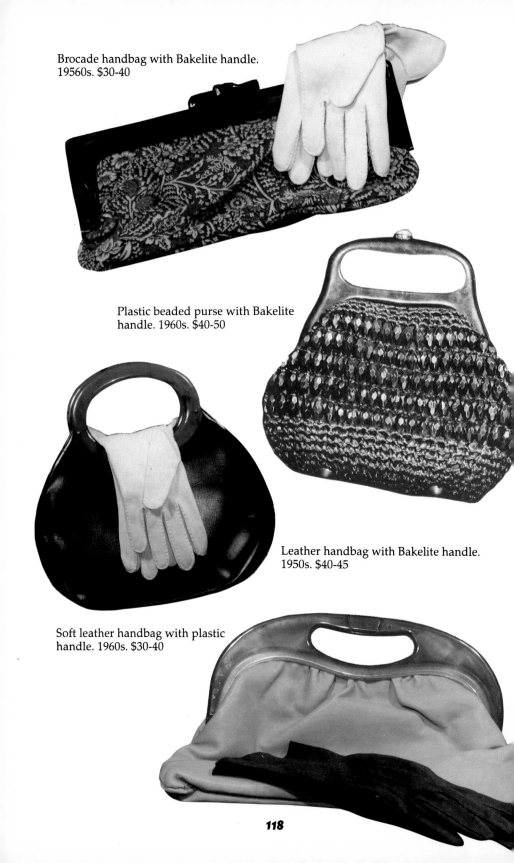

Brocade handbag with Bakelite handle.
19560s. $30-40

Plastic beaded purse with Bakelite
handle. 1960s. $40-50

Leather handbag with Bakelite handle.
1950s. $40-45

Soft leather handbag with plastic
handle. 1960s. $30-40

Children's Items

Plastic apple with leather tie necklace. 1970s. $8-11

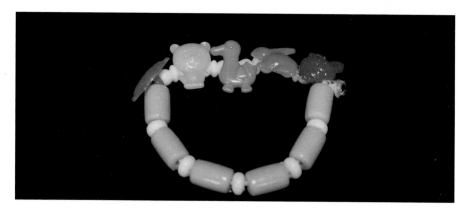

Child's stretch plastic animal bracelet. 1960s. $8-12 set

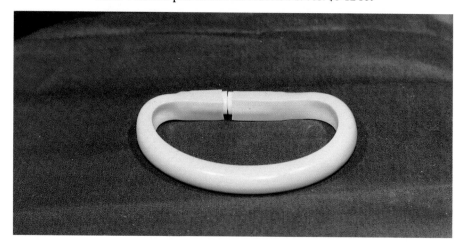

Aqua bendable plastic ink pen bracelet. 1950s. $15-20

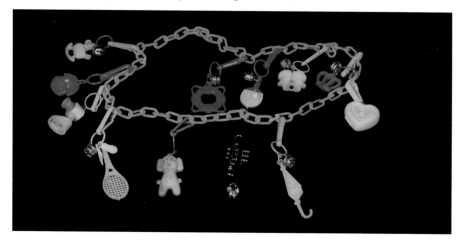

Plastic child's charm necklace. "Taiwan," 1980s. $10-15

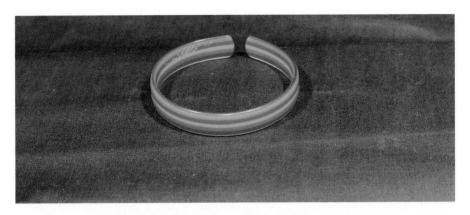

Rainbow bendable plastic child's bracelet. 1960s. $10-12

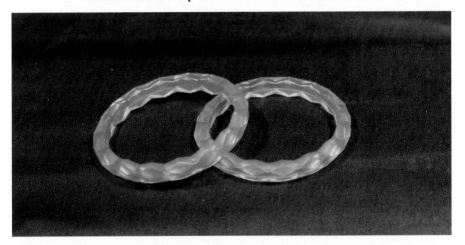

Soft plastic transparent molded child's bracelets. 1950s. $8-12 pair

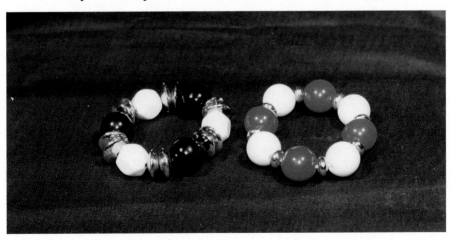

Child's stretch bracelets with plastic beads and gold-tone spacers. 1950s. $8-10 each

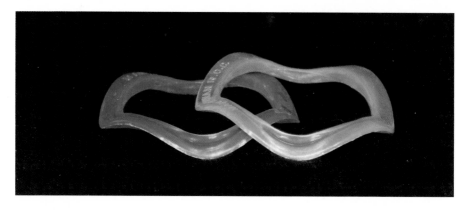

Light weight plastic bangles. Florescent swivel-look. "Taiwan," 1960s. $4-6 each

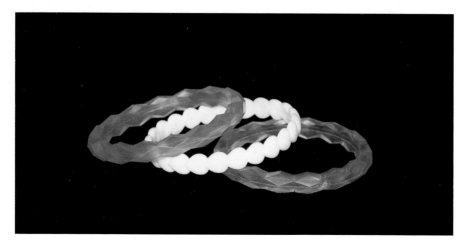

Transparent plastic bracelets. 1970s. $7-12 each

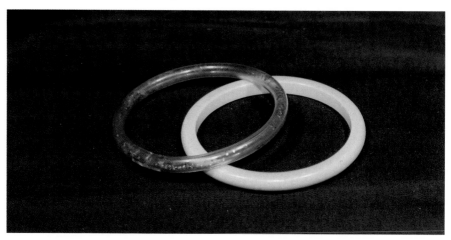

Bendable soft plastic bracelets. 1950s. $12-15 pair

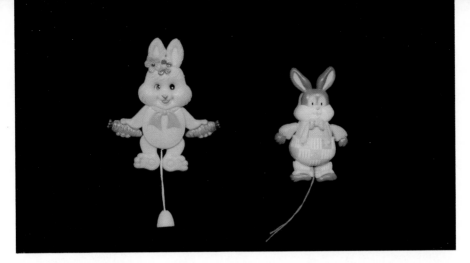

Left: plastic rabbit child's pin. Pull string to make the rabbit dance and his eyes move up and down. 3". Right: plastic bunny child's pin that moves his arms up and down. 2". "Avon". $6-10 each.

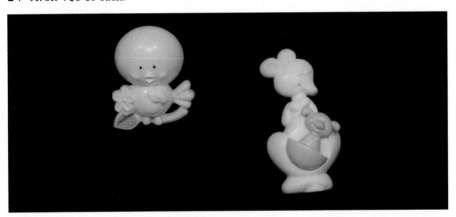

Plastic fragrance pins from Avon. 1975. $6-10

Plastic fragrance pins from Avon. Skunk, 1972; rabbit, 1973; elephant, 1975; yellow bunny, 1976. $6-10

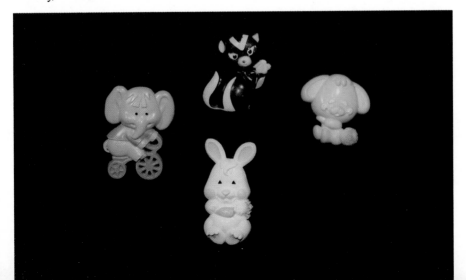

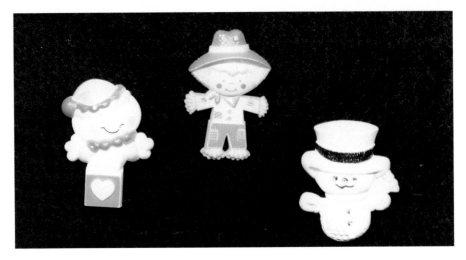

Plastic fragrance pins from Avon. Snowman, 1974; scarecrow, 1975; jack-in-the-box, 1976. $7-12

Plastic "lady's" fragrance pins from Avon. Dark hair, 1970; light hair, 1971; Miss Piggy pin, 1980. $7-12

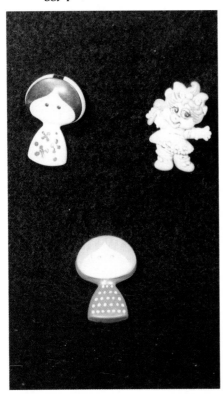

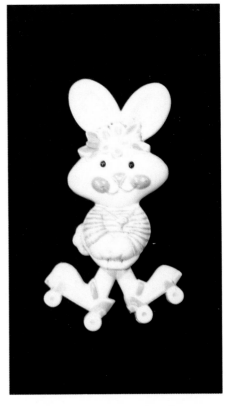

Plastic fragrance pin, roller skating rabbit with moveable legs. 1974. $10-14

Gold-tone kitty on plastic fish bowl with fish inside. "Gold Crown," 1990s. $12-15

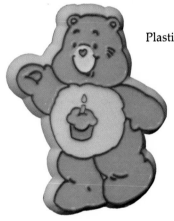

Plastic Care Bear pin. 1983. $3-4

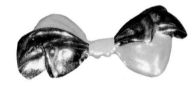

Plastic bow hair clip. 1980s. $6-7

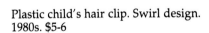

Plastic child's hair clip. Swirl design. 1980s. $5-6

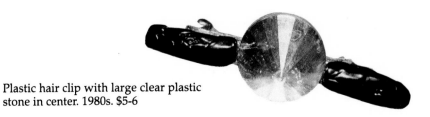

Plastic hair clip with large clear plastic stone in center. 1980s. $5-6

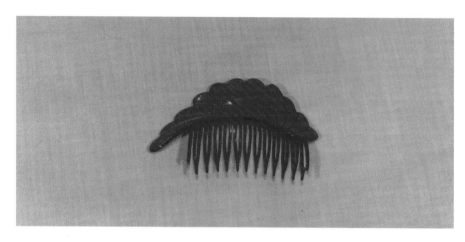

Swirl-look child's barrette. "Made in U.S.A.," 1970s. $4-6

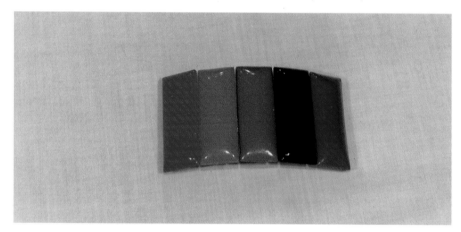

Multi-colored plastic oblong hair clip. 1970s. $8-12

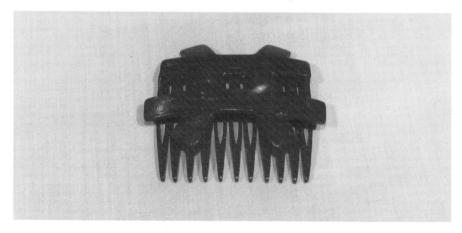

Oriental motif plastic hair comb. 1970s. $5-7

"Bach-Reichmann" oval plastic hair clip. 1960s. $5-7

Plastic swirl design hair clip. "West Germany," 1970s. $8-10

Iridescent floral hair barrette. "France," 1950s. $6-10

Bakelite wavy design hair clip. "France," 1970s. $10-15

Bibliography

Heimann, Erich. *Do It Yourself with Plastics*. New York: Dutton, 1973.

Lambert, Mark. *Spotlight on Plastics*. Vero Beach, Florida: Rourke Enterprises, 1988.

Cope, Wright. *Cope's Plastic Book*. Chicago: Goodheart-Wilcox, 1957.

Buehr, Walter. Plastics: *The Man Made Miracle*. New York: William Morrow, 1967

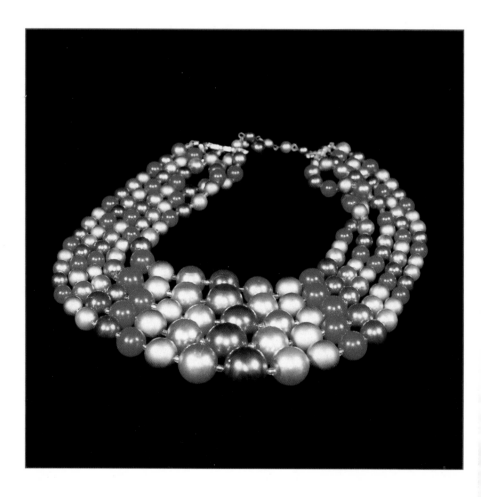